Romanticism: A Very Short Introduction

VERY SHORT INTRODUCTIONS are for anyone wanting a stimulating and accessible way into a new subject. They are written by experts, and have been translated into more than 45 different languages.

The series began in 1995, and now covers a wide variety of topics in every discipline. The VSI library now contains over 500 volumes—a Very Short Introduction to everything from Psychology and Philosophy of Science to American History and Relativity—and continues to grow in every subject area.

Titles in the series include the following:

Michael Ferber

ROMANTICISM
A Very Short Introduction

OXFORD
UNIVERSITY PRESS

OXFORD

UNIVERSITY PRESS

Great Clarendon Street, Oxford ox2 6DP

Oxford University Press is a department of the University of Oxford.
It furthers the University's objective of excellence in research, scholarship,
and education by publishing worldwide in

Oxford New York

Auckland Cape Town Dar es Salaam Hong Kong Karachi
Kuala Lumpur Madrid Melbourne Mexico City Nairobi
New Delhi Shanghai Taipei Toronto

With offices in

Argentina Austria Brazil Chile Czech Republic France Greece
Guatemala Hungary Italy Japan Poland Portugal Singapore
South Korea Switzerland Thailand Turkey Ukraine Vietnam

Oxford is a registered trade mark of Oxford University Press
in the UK and in certain other countries

Published in the United States
by Oxford University Press Inc., New York

© Michael Ferber 2010

British Library Cataloguing in Publication Data

Data available

Library of Congress Cataloging in Publication Data

Data available

Typeset by SPI Publisher Services, Pondicherry, India
Printed in Great Britain by
Ashford Colour Press Ltd, Gosport, Hampshire

ISBN 978-0-19-956891-8

Impression: 15

To Lucy

Contents

Preface

What is Romanticism? A difficult question, as we shall see in Chapter 1. It is tempting to reduce the question to: Who are the Romantics? That seems to have a clear enough answer. Surely they include Wordsworth, Byron, Shelley, and Keats among English poets; Hugo, Lamartine, Musset, and Nerval among French; the Swiss/French Madame de Staël, who popularized the very word 'Romantic'; Germans such as the young Goethe and Schiller, then the Schlegel brothers, the philosopher Schelling, the poets Hölderlin and Novalis; Mickiewicz in Poland; Pushkin in Russia; the composers Schumann, Chopin, Liszt, Berlioz, and Wagner, along with Beethoven and Schubert in some of their phases; the painters Turner, Delacroix, and Friedrich; and in America, Emerson, Thoreau, Fuller, Melville, Poe, Dickinson, and Whitman. With this little list, easily expanded, we already have many of the greatest creative geniuses of the 19th century, still admired, even revered, in the 21st. Most people who talk about Romanticism at all talk about these people, or use them as touchstones to talk about other people. There is little controversy about this list as a first approximation, though nearly everyone on it has attracted at least one perverse scholar who has attacked his or her Romantic credentials.

We could leave it at that, and proceed with a short introduction to these remarkable people and their works. But readers of this

book deserve an attempt to answer the harder question, and learn something about what all these great people have in common – their ideas, beliefs, commitments, tastes – and which traits their works share. Why, after all, do we agree to call these artists and thinkers 'Romantic' in the first place? It only begs the question to put them on the same list. So this book will try to offer some generalizations about the movement, if it was really one movement and not several, that arose in the late 18th century and spread throughout Europe and the Americas by the middle of the 19th. It considers Romanticism from several angles, but seeks to find commonalities from whichever approach it takes.

Still, we should keep the list of geniuses in mind as we go. To risk a generalization right away, Romanticism celebrated genius and unique individuality, so it is bound to be various and quirky. And Romanticism, to risk another generalization, was alert to the limits of discursive reason in the face of 'life', or 'experience', or what Blake called 'Minute Particulars'. As we consider the range and aptness of the categories this book provides, the prickly particularity of even its most 'representative' figures should warn us against anything neat or simple or too abstract.

Acknowledgements

I thank Susan Arnold, Martin McKinsey, and William Stroup for reading all or most of the book and offering many useful suggestions.

List of illustrations

Chapter 1
The meaning of the word

> I cannot send you my explanation of the word 'romantic'
> because it would be 125 sheets long.
>
> Friedrich Schlegel, 1793, in a letter to his brother Wilhelm

Since at least the 1820s, definitions of Romanticism have been sent
aloft, shot down, repaired, relaunched, parodied, abandoned,
rediscovered, finally laid to rest, and revived from the dead through
countless cycles of scholarship and journalism. In his classic
essay of 1924, 'On the Discrimination of Romanticisms',
the intellectual historian A. O. Lovejoy claimed the word
'Romanticism' had come to mean so many things that it now meant
nothing at all, and he urged us to give it up, or at least to use it, as
he does in his title, only in the plural. He investigated three literary
schools or movements, one English, one German, and one French,
to which the term had been habitually applied, and he could find
no common characteristic among them. Influential though he was,
however, Lovejoy attracted more replies than followers, and the
word remains stubbornly ensconced in common speech no less
than in schools and universities, where courses and textbooks
routinely sport it in their titles. There is no getting rid of it – a fact
Lovejoy himself implicitly conceded, for to turn a mass-noun
into a count-noun, to go from 'Romanticism' to 'Romanticisms',
was to admit through the back door what he had shooed out the

front. We were now to count Romanticisms, but how do we know what counts as a Romanticism? Perhaps, many felt, we had better learn to live with the word, in the singular.

Exactly a century before Lovejoy's article, Émile Deschamps, already wearied by the loud and interminable debate in the hothouse world of Parisian journals and cafés, wrote in *La Muse française* in 1824: 'Romanticism has been so often defined that the whole issue has become quite confused enough as it is, without my making darkness darker still with any new attempt at illumination.' In 1836, Alfred de Musset, whose credentials as a Romantic hardly anyone would question today, laid out in *Letters of Dupuis and Cotonet* (as Lovejoy noted) a delightful survey of the many irreconcilable uses of the term during the preceding decade in France. Struck by the recent *éclat* over the word, and especially with its contrast with 'classicism', Musset's characters Dupuis and Cotonet set out to get to the bottom of it and read everything they can find. 'We thought, at first, for about two years, that romanticism as far as writing was concerned only applied to the theater, and that it was distinguished from classicism by not insisting upon the unities' – that is, a single plot, in a single setting, on a single day, which we nearly always find in ancient and neoclassical drama. Soon they are set right. 'But we were told abruptly (this was, I believe, in 1828) that there was romantic poetry and classical poetry, romantic novels and classical novels, romantic odes and classical odes.' After this, they cannot sleep. Then they read a preface by an authoritative writer. 'It was very plainly set forth that romanticism was nothing more than the union of the gay and the serious, the grotesque and the terrible, buffoonery and the horrible; in other words, if you prefer, of comedy and tragedy.' This pleases them; they sleep well afterward. Then Cotonet brings over some volumes of Aristophanes, and they conclude that this ancient Greek comedian who stuffed his plays with anything and everything must have been a romantic! Then they get interested in the word 'romanticism' itself, which they think very beautiful. 'It resembles the words *Rome* and *Roman*,

2

Romance and *Romanesque*; perhaps it means the same thing as *Romanesque*' – but that turns out to be another non-starter. When they learn that Madame de Staël introduced Romanticism to France in her book *On Germany*, one of them announces, 'I think this is what we are searching for. Romanticism is German poetry.' But then, on reading further, they decide they must include English poetry, and then Spanish, and soon they are lost again. They grasp at a few other definitions. By 1832, they think it must be a system of philosophy or political economy. Then 'from 1833 to 1834 we thought romanticism consisted in not shaving, and in wearing waistcoats with long, stiffly starched revers'. Then a scholar tells them,

> Romanticism is the weeping star; it is the sighing wind, the chilly night, the bird in its flight, and the sweet-scented flower; it is the refreshing stream, the greatest ecstasy, the well by the palm trees, rosy hope and her thousand lovers, the angel and the pearl, the white robe of the willows....

Such 'nonsense' leaves them even more baffled, and after a little more research, they settle on the conclusion that Romanticism is 'an abuse of adjectives'.

If we were seeking a very short introduction to French Romanticism, we could do worse than follow this hapless and hilarious research. The 'preface by an authoritative writer' that goes on about the grotesque and the serious, for instance, is the 'Preface' to the play *Cromwell* (1827) by Victor Hugo, who was the centre of Romanticism if anyone was. But what may be missed in this parade of definitions is that, except for the poetic effusion of the scholar, they are all brief formulas that claim to name the common denominator of all expressions of Romanticism. Lovejoy was to deplore the absence of such a formula. There is no law, however, that dictates that definitions must name a common denominator, or that they must be as brief as a phrase or a sentence. There is a more flexible kind of definition that might help

us here, though it might disappoint those who, like Dupuis and Cotonet, wish to tidy up their concepts. Before we turn to it, however, let us look farther down one of the alleys these two researchers stumbled into, the similarity of 'Romanticism' to *Rome* and *Roman*, *Romance* and *Romanesque*'. Although they cannot provide *the* meaning, strictly speaking, the relationships among these words will at least tell us why we ended up with 'Romanticism' in the first place.

It is one of the oddities of etymology that 'romantic' ultimately derives from Latin *Roma*, the city of Rome, for surely the prevalent image of the ancient Romans for many centuries now is that they were the least romantic of peoples. It is then a pleasant irony of cultural history that one of the distinctive themes of writers (and painters) whom we now call Romantic was the ruins of Rome – as in Chateaubriand's *René* (1802), August Wilhelm Schlegel's 'Rom: Elegie' (1805), Staël's *Corinne* (1807), Byron's *Childe Harold's Pilgrimage*, Canto 4 (1812), Lamartine's 'La Liberté ou une nuit à

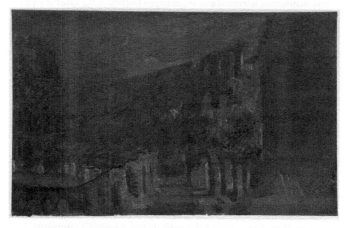

1. J. M. W. Turner, *Colosseum by Moonlight* (1819). A favourite subject of Romantic writers and painters was the ruins of Rome, or the ruins of any ancient building, especially by moonlight

Rome' (1822), and so on – while a large share of the Italian tourism industry today depends on the image of Rome as The Romantic City.

The odd turn in its etymology took place in the Middle Ages. From the adjective *Romanus* had come a secondary adjective *Romanicus*, and from that adjective had come the adverb *Romanice*, meaning 'in the Roman manner', though that form is not attested in writing. Latin speakers in Roman Gaul (Gallia) would have pronounced *romanice* something like 'romanish', then 'romansh', and then 'romants' or 'romaunts'. By then, the Franks had conquered Gaul and made it Francia, or 'France', but the Franks spoke a Germanic language akin to German and Dutch, so 'romants' (spelled *romauns, romaunz, romance,* and several other ways) was enlisted to distinguish the Roman or Latin language of the Gallo-Romans from the Frankish or 'French' of their conquerors. Eventually, of course, the Franks gave up their language and adopted the *romauns* language, and the word 'French' switched its reference from Frankish-Dutch to what we now call Old French, the descendant of Latin spoken in France. Yet the word *romauns* remained in use to distinguish that spoken or vernacular descendant of Latin from the older, more or less frozen, form of Latin used by the church and court. ('Romance' is still the term for all the daughter languages of Latin: French, Italian, Spanish, Portuguese, Romanian, and the rest.)

Romauns had also been applied to anything written in Gallo-Roman (Old French) and, even after 'French' had replaced it as the name for the language, it remained in use for the typical kind of literature written in it, that is, what we still call 'romances', the tales of chivalry, magic, and love, especially the tales of King Arthur and his court. These romances are the ancestors of the novel, and the word for 'novel' in French became *romant* and then *roman*. German, Russian, and other languages have borrowed the French term for 'novel', but English took its term from Italian *novella*, that is, *(storia) novella*, 'new (story)', and restricted

5

'romance' first to the original medieval works, then to works with similar material, such as Spenser's *The Faerie Queene* (1590–6), and finally to a particular kind of novel, such as Scott's *Ivanhoe: A Romance* (1819), Hawthorne's *The Blithedale Romance* (1852), or the 'Harlequin Romances' of today. It is indeed one of the hallmarks of the period of Romanticism's rise that the romance genre was rediscovered and prized, first and especially in Britain. Richard Hurd's *Letters on Chivalry and Romance* (1762) inspired new attention to medieval and Renaissance literature, and soon there were many new imitations in verse, such as Byron's *Childe Harold's Pilgrimage: A Romaunt* (first two Cantos, 1812), Moore's *Lalla Rookh: An Oriental Romance* (1817), and Keats's *Endymion: A Poetic Romance* (1818).

In French, *romant* or *roman* generated several adjectives, such as *romantesque* and *romanesque*, the latter now used in architectural history to refer to the style preceding Gothic. By the 17th century, *romantique* appeared in French and 'romantick' in English, but they did not catch on until the mid-18th century, largely under the influence of James Thomson's poem *The Seasons* (1726–46), translated almost immediately into the main European languages; in it we find 'romantic Mountain', 'romantic View', and clouds 'roll'd into romantic Shapes'. By the 1760s, *romantisch* appeared in Germany, while *romantique* was used in France, sometimes to refer to kinds of literature, as Thomas Warton, Jr, was to do in his *Romantic Fiction* (1774).

When Friedrich and August Wilhelm Schlegel and their circle began writing about *romantische Poesie* in the 1790s, they were hearkening to the old use of *romauns* as a term distinct from 'Latin', for one of the emergent meanings of 'romantic' literature is its contrast with 'classic' literature, that is, Greek and Latin literature. Friedrich, the more theoretical of the brothers, did not quite use 'romantic' as a period term. He denied that he identified 'romantic' with 'modern', for he recognized some contemporary writers as classical; rather, 'I seek and find the

romantic among the older moderns', he wrote, 'in Shakespeare, in Cervantes, in Italian poetry, in that age of chivalry, love, and fable, from which the phenomenon and the word itself are derived' (*Dialogue on Poetry*, 1800). In his circle, however, *romantisch* became nearly identified with 'modern', or 'Christian', as opposed to 'ancient', while sometimes it was narrowed to a sense connected to *Roman* as 'novel' and meant 'novelish' or 'novelic', the novel being a characteristically modern genre.

Thus launched as a term for a trend in literature, 'Romantic' within a decade or two was received and passionately debated throughout Europe. It is worth remembering, in view of the indelible label later generations have given them, that in Britain neither the exactly contemporaneous 'Lake School' (Wordsworth, Coleridge, Southey, Lamb) nor the next generation (Byron, Shelley, Keats, Hunt) nor anyone else called themselves Romantics at the time. This is true of groups throughout Europe, even of the Schlegel circle: if we restricted ourselves to authors, painters, and musicians who called themselves 'Romantic', we would have a nearly empty set. Thanks especially to Madame de Staël's *De l'Allemagne* (*On Germany*) (1813), however, which reported her encounters with the 'Romantic' school as well as with Goethe and Schiller, the romantic/classic distinction entered European discussion permanently. By 1810, *romanticeskij* was in use in Russia; by 1814, *romantico* in Italy; by 1818, *romantico* in Spain. In his 1815 Preface to his *Poems*, Wordsworth distinguished between the 'classic lyre' and the 'romantic harp'; these musical instruments became common tokens for contrasting artistic commitments, as we find as well in Victor Hugo's 'La lyre et la harpe' (1822).

That is more or less how we got the word. The question returns: when we use it to refer to a literary movement or school, as opposed to a mountain or a cloud, does it have, or can we give it, a satisfactory definition? After nearly two centuries, of course, we have acquired a sense for the people and ideas that should be subsumed under it, but they are so many and various that it seems

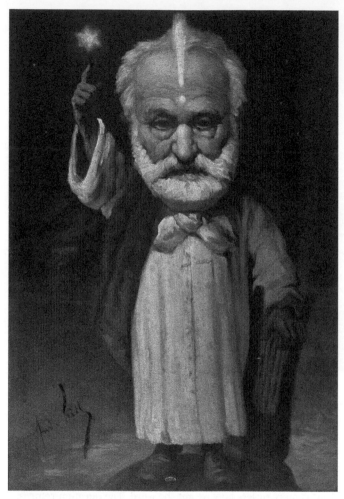

2. André Gill, *Victor Hugo as a Mage* (1880). As he reached
old age, Victor Hugo assumed the mantle of prophet and founder
of a new religion. In Gill's caricature, he is in classical/priestly garb,
holding his lyre, pointing to a star of Poetry, herald of Liberty
(as he had proclaimed in his poem 'Stella'), and with an
exclamation point on his brow

hopeless to search for a single universal feature. The labours of the Dupuises and Cotonets and Lovejoys have taught us that much. I agree with those who think we can approach the problem more constructively if we adopt a less stringent definition of 'definition' itself, along the lines of Ludwig Wittgenstein's notion of 'family resemblances'. In a family of ten people, for instance, there may be five or six distinctive facial or bodily features that recur among them, but it might happen that two or even three members have no such feature in common. They might each have two or three of the family traits, but not the same two or three. The other members of the family may each have four or five of them, so there are many overlaps, and when you have had a good look at, say, five members of the family, you are likely to pick out the other five from a crowd. A definition based on this idea would amount to a list of distinctive traits, with some ranking as to importance and generality, but no one trait, maybe not even two or three, would be definitive.

In an influential reply to Lovejoy in 1949, René Wellek proposed three traits or 'norms' shared by those authors whom we call Romantic: imagination for the view of poetry, nature for the view of the world, and symbol and myth for poetic style. Some whom we want to call Romantic, he concedes, elude one criterion or another: Byron did not see the imagination as the fundamental creative power, and 'Blake stands somewhat apart' with regard to nature (surely an understatement, as 'Nature' in Blake is always a barrier to 'Imagination'). But these three norms are found quite widely across European literature, and those who display one of them usually display the other two. Wellek shares with Lovejoy the same notion of what a definition is, except that in Wellek's view, it is not one trait we are looking for but three. (Or rather, since the three are interlinked, they are really one, though a fairly complicated one, which may not be fully expressed in each Romantic.) Wellek's case is embarrassed by the exceptions he cites, however, for if Byron is not a Romantic, or only two-thirds of a Romantic, then we need to think again.

Yet Wellek's triad of traits may be recuperated under the 'family resemblances' model, and we could do worse than begin a list with it. Harold Bloom has claimed that Romanticism is 'the internalization of quest romance', a transformation of the heroic quests in medieval romances into interior spiritual journeys. Childe Harold, the hero of Byron's *'romaunt'*, written in Spenserian stanzas that evoke the action-filled *Faerie Queene*, does not do anything very heroic, and his 'pilgrimage' has no destination; he travels around Europe and meditates on what he finds. Not least because it enlists the etymology of 'romantic', Bloom's phrase belongs on our list after Wellek's three traits. Also on the list would be the wonderful title of M. H. Abrams's important book (by way of Thomas Carlyle), *Natural Supernaturalism* (1971); it evokes the belief of English and German poets and philosophers that the divine is immanent in nature, as well as in the human psyche, as opposed to being transcendent in God – a belief T. E. Hulme had already dismissed as 'spilt religion'. A few phrases like these, rounded out with a few frequent themes or images or settings, such as Roman ruins or aeolian harps (see Chapter 2), would give us a useful and flexible set of markers without drawing us back into fruitless debates over the essence or common denominator of Romanticism.

Here is an effort at a definition, then, at a fairly abstract level, in a one-sentence but multi-claused paragraph:

> Romanticism was a European cultural movement, or set of kindred movements, which found in a symbolic and internalized romance plot a vehicle for exploring one's self and its relationship to others and to nature, which privileged the imagination as a faculty higher and more inclusive than reason, which sought solace in or reconciliation with the natural world, which 'detranscendentalized' religion by taking God or the divine as inherent in nature or in the soul and replaced theological doctrine with metaphor and feeling, which honored poetry and all the arts as the highest human creations, and which rebelled against the established canons of

neoclassical aesthetics and against both aristocratic and bourgeois social and political norms in favor of values more individual, inward, and emotional.

Perhaps this will join the long list of deflated definitional balloons some day. It could certainly be improved: thickened, for instance, with some concrete themes and forms that recurred across the movement, or movements. But it will do as a first approximation.

Similar difficulties have arisen in the definitions of Romanticism in music and the visual arts, made worse because they have usually tried to stay in tandem with the uncertain meaning of Romanticism in literature. I will have more to say about both domains later in this book, but will note here that, while they would seem to compound our problem of definition if we seek one that embraces all the arts, nonetheless, if we take them all together, they may help us see characteristic patterns of forms and styles, as opposed to themes or symbols, in Romantic literature. The painters and composers are as various and idiosyncratic, no doubt, as the writers, but when they are brought onto the stage to join the writers, we notice such family traits as the 'musicalization' of the other arts, parallel to the 'lyricization' of non-lyrical forms of literature; the rise of short forms; and the prominence of deliberate fragments (see Chapter 6). As for literary themes, many of them are expressed in the other arts, such as the consecration of the artist in self-portraiture, in virtuoso performances (by Paganini, Liszt, and Chopin), and in 'confessional' music (such as Berlioz's *Symphonie Fantastique* and *Lélio*); or wild nature found in landscape painting and in music that evokes an outdoor setting (notably in Berlioz and Liszt), as well as in settings of songs about nature and wandering. And, of course, there are other domains besides the arts that were both causes and effects of Romanticism, such as philosophy and political theory, the collection of folklore and the historical study of language and culture, and even the sciences.

This book deals with Romanticism in the time of its incubation, birth, and growth in Western Europe, the time midway through which it began to speak its name: roughly 1760 to 1860. It is common to speak of some such dates as the 'Romantic Period' or the 'Age of Romanticism', though it will vary from country to country and from art to art. It is harmless enough to name periods with such terms as 'Romantic', 'Augustan', 'Renaissance', 'Modern', or 'Post-Modern' if it is clear that one is conferring a certain distinction on a major cultural trend but is not necessarily claiming that it had a monopoly. Yet one can easily slide without thinking into a notion of cultural homogeneity or at least the assumption that everything was touched by 'the spirit of the age', in William Hazlitt's phrase, or the *Zeitgeist*. Strained efforts to show that Jane Austen or William Godwin was a Romantic often show this unexamined assumption at work. In any period, there will be various norms, trends, tastes, or schools, and at times none of them will be dominant. Just when Romanticism became dominant, as most scholars think it did, is not easy to decide. For Britain, we often open the period at 1789, the date of Blake's *Songs of Innocence* that also nicely coincides with the beginning of the French Revolution, but Blake went unnoticed until well after his death and is not altogether a Romantic anyway, as Wellek noted. The year 1798 looks like another good starting date, the year of Wordsworth's and Coleridge's *Lyrical Ballads* that happily coincides with the formation of the Schlegel group in Jena. But it took some years for their book to make its mark; it was not a bestseller. It might not be until 1812, then, when Byron awoke to find himself famous for *Childe Harold*, that we can rightly claim that Romanticism became the prevalent complex or norm, though Byron would have been astonished to hear it. The closing date of British Romanticism is often taken to be 1832, with the Reform Bill as the marker, but with a sense that the recent deaths of the three younger Romantics, Keats, Shelley, and Byron (not to mention Blake), put an end to something. But is Tennyson (the poet laureate after Wordsworth) not a Romantic? The Brontës? Surely Romantic norms were spreading everywhere even as new

norms were taking shape. What we call the Victorian Era, on the doubtful assumption that the regnal dates of a monarch meaningfully name a coherent culture, might rightly be called Romantic. Yeats (who died in 1939) called himself one of 'the last Romantics', but that may well have been a premature judgement. Looking to other countries, and to the other arts, we see the same complexities recurring and compounding each other, while offering telling parallels. It is sometimes argued of French Romanticism that it started twice, first with Chateaubriand, then twenty years later with Lamartine. Some scholars have denied that Italy ever had a Romantic movement, though it is undeniable that some of its writers exhibit some of the family features. It is sometimes claimed that Spain had a second Romantic movement towards the end of the 19th century. Romanticism in America, which we will only touch on in this book, gets under way at least a generation after its British counterpart. Romantic music is often said to span the whole century, while Romantic painting is usually confined to less than half of it. But all of this slippage of labels need not concern us much if we keep distinct the two referents of the term: a period of time, on the one hand, and a set of distinctive beliefs, sentiments, norms, and themes, on the other. This book is about the latter, as they first manifested themselves at a particular time.

Chapter 2
Sensibility

The lumping of all literature, and indeed all the arts, into two modes, 'classic' and 'romantic', which we owe to the Schlegels and their friends in Jena, and to Mme de Staël's report on German writers, has hovered for two centuries over discussions of the cultural history of Europe and North America. What Carlyle in 1827 called the 'grand controversy, so hotly urged, between the *Classicists* and *Romanticists*' was often revisited, generations later, when distinctions needed to be drawn in polemical reviews and manifestos. When T. E. Hulme and his 'Imagist' circle in the first years of the 20th century, for example, dismissed the damp and gaseous Romanticism of Hugo and the late Victorians, they did so on behalf of a dry, hard 'classical' style. The line between the modes was drawn and redrawn constantly – even the Schlegels kept revising their definitions – and many were sceptical of the usefulness of these all-embracing terms, but such binary categories are tenacious, and with so much smoke it seemed there must have been a real fire somewhere, a real difference between two cultural styles.

And certainly, it is not hard to see it, if one stands at a certain distance and fearlessly generalizes. The deference to the forms and 'rules' of Greek and Latin authors, especially Latin, with their clarity, focus, and decorum; the assumption that literature, and all the arts, should be an ideal imitation of life, or 'Nature

methodiz'd' (in Alexander Pope's phrase), and that their purpose is to improve our morals by purging tragic passions or ridiculing comic vices, including religious 'enthusiasm'; the acceptance of human limitations and the necessity of order in both the arts and society, though often tempered with a modest hope that civility and reasonableness may enlarge their domain – these norms were widespread in the 17th and early 18th centuries among the literate elite of Europe. They are bound up at many points with the norms of the Enlightenment, which was extending the recent triumphs of astronomy, physics, and mathematics, especially those of Sir Isaac Newton, to any and every terrain, including religion, society, and psychology.

Romanticism, it is commonly thought, rebelled against both classicism and the Enlightenment (we think of William Blake denouncing Homer and Virgil, on the one hand, and Bacon, Newton, and Locke, on the other), and yet many Romantic writers and artists deeply admired classical literature, sculpture, and philosophy, and eagerly followed contemporary research in the sciences. It is a mistake, above all, to see Romanticism as simply succeeding classicism, or the Enlightenment, as if the 18th century were all of a piece. For scholars today deploy another term, 'Sensibility', to name a development within and against classical norms beginning in the mid-18th century. 'Sensibility' does not mean sensibleness or common sense, as it might in today's English, but sensitivity or emotional responsiveness, bordering on sentimentalism, as opposed to reasonableness and detachment, painted as cold rationality and heartless wit. We then get a three-part periodization, in Britain at least: Classicism or Neoclassicism, sometimes also called the Augustan Age (1660 to 1740 or so), then Sensibility (1740 to 1789), and then Romanticism (1789 to, say, 1832). This, too, is an oversimplification, of course, but it is not terribly misleading, as long as we remember that the dates are arbitrary (and based on political events) and that the three styles or modes overlapped for decades. The same phases are traceable in Continental literature, though with different dates.

For a time, literary historians called the middle phase 'Pre-Romanticism', as if the trends they observed were somehow incomplete, still germinating or sprouting, awaiting time and favourable weather to flower into full-blown Romanticism. That idea is itself Romantic enough, for one of the characteristic metaphors of Romantic thought is the organism, and especially the plant, as a model for society, history, and the making of art. But we would be wise to heed Northrop Frye's warning against imposing a 'false teleology' on the period, for 'Not only did the "pre-romantics" not know that the Romantic movement was going to succeed them, but there has probably never been a case on record of a poet's having regarded a later poet's work as the fulfillment of his own.' Some French scholars call the equivalent phase in France the 'first Romanticism', but let us call it 'Sensibility', and take it as just as 'complete' as any other movement, while looking for sources of what did in fact succeed it.

Sympathy, melancholy, and horror

Its defining feature, then, was the value it placed on feeling, and especially fellow-feeling or sympathy, as opposed to reason, as the basis of our moral and social life. Certain very reasonable philosophers, such as the Earl of Shaftesbury, David Hume, and Adam Smith, argued that the heart, which prompts us without reflection, was a better source of good character and right action than the intellect, which calculates consequences or prudently obeys codes of conduct. In his *Characteristicks of Men, Manners, Opinions, Times* (1711), Shaftesbury claimed we have an innate 'moral sense' that works something like an aesthetic sense or taste:

> It feels the soft and harsh, the agreeable and disagreeable, in the affections; and finds a foul and a fair, a harmonious and a dissonant, as really and truly here, as in any musical numbers, or in the outward forms or representations of sensible things.

In the end, our reason and our moral sense should come into harmony, and it takes cultivation, not suppression, of our natural impulses to bring that harmony about. He also sharply criticized the egoistic theory of morality he found in Thomas Hobbes, for example, as well as in the Christian belief that we should be virtuous because God commands us to be virtuous and will punish us if we are not. Our natures lead us, often if not always, to act altruistically, with spontaneous impulses to be generous, sociable, or helpful. Jean-Jacques Rousseau, who might fairly be called the grandfather of Romanticism, agreed that acts of conscience are feelings, not judgements, and that we have a natural sympathy for the sufferings of others. As Thomas Warton, Jr, put it in 'The Pleasures of Melancholy' (1747), 'at a brother's woe / My big heart melts in sympathizing tears' ('big' here meaning 'swollen'). Copious tears flowed down male as well as female cheeks throughout the age of Sensibility both in literature and in life. Spontaneity itself was a virtue, and it was to be found among simple village folk who lived closer to nature than the urban middle and 'gentle' ranks, or among old texts that recorded the culture of times before the artificiality of cities and courts corrupted it. In this spirit arose the vogue to collect folk tales and folk songs, which led notably to Thomas Percy's *Reliques of Ancient English Poetry* (1765), consisting mainly of ballads; it had a wide and deep impact both in Britain and on the Continent.

Sensibility, being a state of mind, might not reveal itself in anything but sympathizing tears, so it is not surprising that novels of this period tended to leave behind the episodic action-filled plots of, say, Defoe, and take an inward turn, where the action was thinned and slowed and served largely as occasions for contemplation and conversation. Hence the epistolary novel, or novel of letters, gained new prominence. Samuel Richardson's *Pamela; or, Virtue Rewarded* (1740-1) and *Clarissa; or, History of a Young Lady* (1747-8), were enormously successful; readers identified passionately with their beleaguered heroines and wallowed in their long and intimate examinations of their minds

17

and hearts. Richardson inspired Rousseau to write *Julie, or the New Héloise: Letters of Two Lovers who Live in a Small Town at the Foot of the Alps* (1761), which caused an even greater sensation across Europe. The letters between Julie and her tutor Saint-Preux, filled with passion, psychological acumen, and moral scrupulousness, enraptured readers everywhere, especially women. Richardson and Rousseau were both spurs to Goethe's *The Sorrows of Young Werther* (1774), the most intense of the letter novels (and much the shortest); it recounts the hopeless love of the intelligent and amiable but emotionally self-indulgent Werther for the beautiful and sensible Lotte, already betrothed when he meets her. She returns Werther's love in a troubled and ambiguous way, but she remains faithful to her fiancé; after an emotionally lacerating scene, in which he reads to her his translation of the poetry of Ossian, Werther returns to his rooms and shoots himself. This novel too caused a sensation, and made Goethe the leader of what came to be known as the *Sturm und Drang* ('Storm and Stress') movement, named after a play by Friedrich Klinger (1776), filled with ungovernable emotions and tragic urges for love, freedom, or revenge. It was widely believed, though in no case confirmed, that several young men in Germany and elsewhere were found dressed like Werther and slumped over a book with a bullet in their brains.

Goethe's novel should have served as a warning to young people to bring their passions into some sort of harmony with their reason or common sense. That sort of cultivation, which had been central to Shaftesbury's moral theory, became central to Goethe's outlook as well, as he rapidly outgrew his stormy sensibility and strove instead for a more classical balance and grace. Already by 1778, in fact, he was satirizing his own recent enthusiasm in a play called *Der Triumph der Empfindsamkeit* (*The Triumph of Sensibility*). Within a decade, he and his friend Friedrich Schiller were studying the arts of the ancient Greeks and striving for what they took to be the Greek union of morality and beauty. In 'On Grace and Dignity' (1793), Schiller defined 'the beautiful soul' (*die schöne*

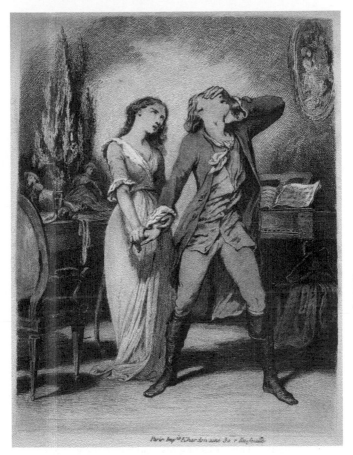

3. Illustration in an 1844 edition of Goethe's *Sorrows of Young Werther*, showing the distraught Werther in the throes of his hopeless passion for Lotte, whose love for him is restrained and platonic. Etching by Tony Johannot

Seele) as one in which 'sensuality and reason, duty and inclination, are harmonized, and grace is its expression in appearance'. To gain a beautiful soul requires cultivation or edification (*Bildung*), a process he elaborated further in his influential *Letters on the Aesthetic Education of Man* (1795). Neither an individual nor a nation will be capable of living in freedom or as a republic of equals (he is thinking of the violence brought about by the French Revolution) until they overcome the conflicts within them, that is, until they reconcile their 'sensuous drive' and their 'form drive', and that is the task of culture and the unifying impulse in the 'play drive', an aesthetic instinct detached from need or duty. Hence – and this thought the early German Romantics made their own – the crucial role of the arts in the growth of the individual and collective spirit. 'Beauty alone makes the whole world happy, and each and every being forgets its limitations while under its spell.'

That was one direction taken by the culture – or cult – of Sensibility. A very different path was the cultivation of 'melancholy', and the indulgence in its 'pleasures', as Warton's title announced. Wandering into groves or ruins or graveyards at evening or sitting by the lamp in one's study and pondering the brevity and sorrows of life – these became common settings and themes in poetry, novels, and paintings. The melancholic soul might meditate on death as the great leveller, as Gray does in 'Elegy Written in a Country Churchyard' (1751), the most famous English poem of the time: 'The boast of heraldry, the pomp of power, / And all that beauty, all that wealth e'er gave, / Awaits alike the inevitable hour. / The paths of glory lead but to the grave.' Wherever his or her thoughts might lead, the melancholic soul was not simply sad or gloomy, however, but rich in wisdom, benevolent towards frail fellow mortals, sometimes even 'rapt' or 'transported' (increasingly frequent words) by the religious vision evoked by the meditative mood.

It seemed to observers as early as about 1700 that a wave of serious, even suicidal, depression had spread across England, and not just

among authors or other 'geniuses'; similar epidemics were noticed in other countries of Europe. In the early 18th century, English borrowed 'ennui' from French to refer to one form of this malaise (another French word); later in the century, the French borrowed 'spleen' from English for a similar state (in the mid-19th century, Baudelaire, heir to the Romantics, used it for his disgust with life in modern Paris). Whether or not there was such an epidemic – and we have no reliable statistics – we are concerned with a milder literary form of melancholy that it was held a privilege to be touched by. James Thomson wrote of the 'sacred influence' of 'the Power / Of Philosophic Melancholy' ('Autumn', 1730), and the term became almost synonymous with philosophy itself, and with religious introspection. Something of its redemptive and spirit-building character remained through most expressions by the Romantic generations. Keats's 'Ode on Melancholy' (1819), for instance, urges us to drink in 'the melancholy fit' without trying to muffle it or distract ourselves, for from it we gain, not philosophic serenity, but sheer intensity of life. In 1802, another wave of literary melancholy was set rolling in France by Chateaubriand's *Génie du Christianisme* (*Genius of Christianity*), in which he describes the *malaise* of the age:

> We are undeceived without having enjoyed life...Imagination is rich, fertile, and marvelous; life is poor, arid, and disenchanted. We dwell, with a full heart, in an empty world; and, without having enjoyed anything, we are disabused of everything.

Poems to or about melancholy were common in Britain, Germany, and France, ranging in mood from resolute embrace of it to deep despair, as in Coleridge's well-known 'Dejection'.

Melancholic contemplation of graveyards, not surprisingly, also sometimes led to a not very philosophical sort of horror. Edward Young's poem *The Complaint; or Night-Thoughts on Life, Death, and Immortality* (1742) (in nine long 'nights') frightened many readers. Man leads his life, Young tells us, 'where deep Troubles

toss, / Loud Sorrows howl, invenom'd Passions bite, / Rav'nous Calamities our Vitals seize, / And threat'ning Fate wide opens to devour.' As if this were not enough, soon novelists were adding ghosts and other uncanny beings and events to create the genre we call the 'Gothic' novel. The first of these was Horace Walpole's *The Castle of Otranto: A Gothic Story* (1764), where at a breathless pace, with abrupt and unmotivated turns of plot, we read a terror-filled story of mysterious murders, ancestral curses, incest, giants, and sheer villainy. Many similarly scary novels soon followed, notably Matthew Lewis's *The Monk* (1796); the most successful of them, of course, is *Frankenstein* (1818), by the youthful Mary Shelley.

A ballad collected by Thomas Percy called 'Sweet William's Ghost' tells the story of the ghost of 'thy true love Willie' at Margaret's door attempting to persuade her to pledge her 'faith and troth'. Margaret at first seems to rebuff him, but then admits him. She then asks if there is room for her at his head or feet or side; there's no room, he replies, 'My coffin is made so meet.' He vanishes at dawn; she begs him to stay; she turns pale, closes her eyes, and dies. This ballad roused the German poet Gottfried August Bürger to write the most famous and most 'Gothic' of all ballads, 'Lenore' (1774). It is much longer than Percy's ballad: the stage is set with the betrothed Lenore disconsolate over the failure of her soldier-lover to return, to the point where she spurns the comforts of Christian faith, after which Bürger describes in thickly rhymed and alliterative verse the wild ride of Lenore with her Wilhelm on his black horse, past a funeral, past a gallows, to her grave. It caused a tremendous stir. Half a dozen translations appeared in English in 1796 alone, one by Walter Scott, who later said that 'Lenore' inspired him to become a poet. After reading another translation, Charles Lamb wrote to his friend Coleridge, 'Have you read the Ballad called "Leonora" in the second Number of the 'Monthly Magazine'? If you have !!!!!!!!!!!!!!' (that's fourteen exclamation points). Within a year Coleridge was writing 'The Rime of the Ancyent Marinere' and his collaborator Wordsworth

was composing the first of his 'lyrical ballads', including several with supernatural themes. Zhukovsky made three versions of 'Lenore' in Russian between 1808 and 1831; Pushkin's 'The Bridegroom' (1825) imitates its unusual stanza and its grisly theme but contrives a happy ending. Mme de Staël praised 'Lenore' in her book on German literature, and before long translations appeared in French. Victor Hugo's ballad 'La Fiancée du Timbalier' (1825) is based on the opening situation: the fiancée, into whose hopes and fears we get intimate glimpses for several stanzas, fails to see her beloved among the returning ranks of troops and falls down dead. This ballad by Bürger almost single-handedly launched the European-wide Romantic vogue, not so much for collecting folk ballads, but for writing new ones. The Germans called the new form the *Kunstballade*, or 'art ballad'. It also launched the 'wild ride' theme, most famously in Goethe's poem 'The Erlking' (1782), a three-part dialogue between a father and his ailing son, hastening home together on horseback, and the king of the elves, who calls out to the boy to come away with him; it was brilliantly set to music by Schubert in 1815.

The rise of Sensibility led, too, to the curious fad for the aeolian harp, or wind harp. It was invented by the German Jesuit Athanasius Kircher and described by him in 1650. Designed to be placed in a window, where it would catch the breezes, it was a long wooden box with strings stretched over two bridges. It could be tuned variously, but even if it was tuned to unison it produced chords when the wind played across it. By the mid-18th century, it was to be seen in many windows and in many poems, such as James Thomson's 'Harp of Aeolus' (1748). It was the perfect metaphor for the sensitive soul, alive to every influence, especially when it seemed to moan in sympathy with the wind. Indeed, it seemed more than a metaphor, for many philosophers and scientists were claiming that the nervous system, including the brain, was an intricate mechanism of vibrating cords, or chords. Poets, as the Romantics in every country were to claim, were exquisitely strung instruments responsive to every inspiring breeze.

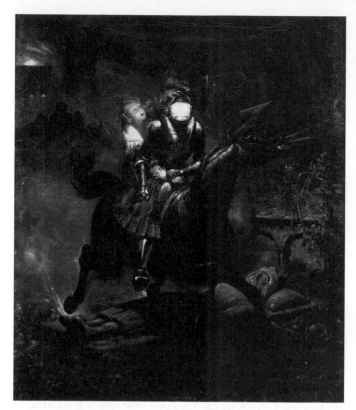

4. Horace Vernet, *The Ballad of Lenore* (1839). For more than 60 years, the scary ballad by Bürger (1774) inspired paintings, musical settings, and more ballads. Here, Lenore is taken on a wild ride by her lover to a grave that will hold them both

The cult of Ossian

As profound an influence on Romanticism as any of the trends and works we have mentioned is James Macpherson's collection and translation (or so he claimed) of the Gaelic songs from the Scottish highlands originally composed by the ancient bard Ossian, and

because it is almost forgotten today I want to dwell on it here. The first bits, translated into prose, appeared in a slender volume in Edinburgh in 1760: *Fragments of Ancient Poetry, Collected in the Highlands of Scotland, and Translated from the Galic or Erse Language*. The public response, especially in Scotland, was so enthusiastic that more poetry, much longer and not very fragmentary, came out every year or two for the next decade. Soon the names Ossian, Fingal, Oscar, Selma, Cuchullin, and Oithona were as well known to readers as Achilles and Agamemnon, and indeed Ossian was proclaimed as 'the Homer of the North'. The bleak Scottish landscape and even bleaker weather; the often mysterious events, sometimes only implied as backgrounds to the tragic love affairs and murders of the foreground; the elegiac mood, as Ossian and the other bards sing of the great warriors and bards of days gone by; the supernatural visitations of these past heroes; and the utter absence of gods (in this very unlike Homer) or any sort of consolation for the tragedies of this world – these sent readers into raptures across Europe.

Even more affecting was the poetic prose. Here is an excerpt from the lament of the bard Alpin, 'the son of song', over the fallen warrior Morar:

> Narrow is thy dwelling now; dark the place of thine abode. With three steps I compass thy grave, O thou who wast so great before! Four stones, with their heads of moss, are the only memorial of thee. A tree with scarce a leaf, long grass which whistles in the wind, mark to the hunter's eye the grave of the mighty Morar. Morar! Thou art low indeed. Thou hast no mother to mourn thee; no maid with tears of love. Dead is she that brought thee forth. Fallen is the daughter of Morglan.

If we rearranged it as verse, it would look like this:

> Narrow is thy dwelling now;
> dark the place of thine abode.
> With three steps I compass thy grave,

O thou who wast so great before!
Four stones, with their heads of moss, 5
 are the only memorial of thee.
A tree with scarce a leaf,
long grass which whistles in the wind,
 mark to the hunter's eye the grave of the mighty Morar.
Morar! Thou art low indeed. 10
Thou hast no mother to mourn thee;
 no maid with tears of love.
Dead is she that brought thee forth.
 Fallen is the daughter of Morglan.

In this form, the parallelisms stand out, where one line or pair
of lines is restated by the next. The simplest pattern is in lines 1
and 2. Not that 'narrow' and 'dark' are synonyms, but they are
comparable opposites of the large and bright hall or castle that
Morar recently made his abode. The most complex pattern is in
3 to 9, with 'three steps' (itself an expansion of 'narrow') parallel to
'four stones' and with 'A tree' parallel to 'long grass', but then
'memorial' (6) is matched by 'grave' (9). To be more precise,
'memorial' implies a place to be seen by others, so the tree and grass
'mark' the grave 'to the hunter's eye'. Of course, it will be only an
occasional hunter, for this is a desolate spot, and those who
ought to be mourning at the grave are dead themselves.
Macpherson was fond of describing a place, usually a tomb, as seen
by another, such as a hunter or mariner, a trick picked up by
Blake in England and Ugo Foscolo in Italy, among others. The final
line of 'The Songs of Selma', from which this passage is taken,
reads: 'The dark moss whistles there, and the distant mariner sees
the waving trees.'

While the scenery was exotic, readers of this passage and many
others like it were on familiar ground, not only that of Sensibility,
with its evocation of the 'tears of love' that will *not* be shed by a
maid, but that of the Bible, with its repetitions with variation.
Open the Psalms at random and you are likely to find Ossianic

couplets: 'Give ear, O my people, to my law: incline your ears to the words of my mouth. I will open my mouth in a parable: I will utter dark sayings of old' (78:1–2). In 1753, Robert Lowth had published a book describing the structure of Hebrew verse in the Old Testament, with its 'parallel members'. The book was well known, and Macpherson was surely familiar with it, though of course he might not have needed it, having grown up with the King James translation of the Bible itself.

This combination of the strange and 'ancient' world of the Gaels with the moods of Sensibility and the rhythms of the Old Testament was irresistible. It was also too good to be true. There were doubters from the outset, and Macpherson was unable to produce most of the original Gaelic texts from his notes. The best-known early sceptic was Samuel Johnson, who declared the poems 'as gross an imposition as ever the world was troubled with'. A generation later, in 1815, Wordsworth mocked Macpherson as 'Sire of Ossian', and wrote:

> Having had the good fortune to be born and reared in a mountainous country, from my very childhood I have felt the falsehood that pervades the volume imposed upon the world under the name of Ossian. From what I saw with my own eyes, I knew that the imagery was spurious.

The consensus today is that Macpherson did indeed hear some Gaelic songs with some of the characters and events he presents in his 'translations', but most of it, guided by his theory that the songs were fragments of an ancient cycle, was his invention. Despite the widespread doubt, many readers, including many Romantic poets, believed in Ossian's authenticity, and even when they were disabused, they continued to admire Macpherson's work.

In Germany, Friedrich Gottlob Klopstock, whose poetry marked a decisive break with neoclassical norms and heralded what

became the dominant Romantic mode, wrote (in 1767) 'Ossian's works are true masterpieces. If only we [Germans] could find such a bard!' He considered Ossian to be virtually German, however, as he took the ancient Celts (Gaels in Ireland and Scotland) and the ancient Germans to be the same people. He and his circle called themselves 'bards'. Bürger translated several sections of Ossian. Goethe translated many pages into verse and prose, then translated 'The Songs of Selma' again for Werther to read to Lotte on their fateful night, though by the time Goethe wrote *Werther*, he had come to see Ossian's limitations: it was a sign of Werther's descent into hopeless infatuation and self-regarding melancholy that he put aside his sunlit Homer to take up his nebulous Ossian. The poet Friedrich Hölderlin wrote to a friend in 1787:

> Something new! A beautiful, beautiful heart-stirring novelty! I have
> Ossian, the bard like no one else, Homer's great rival I have actually
> in my hands. You must read him, friend – then your valleys will
> become Cona's valleys, your Engelberg a mountain of Morven. Then
> so sweet and melancholy a feeling will slowly come over you.

The first poem in Karoline von Günderode's 1804 collection, *Gedichte und Phantasien*, is a verse translation, 'Darthula, after Ossian'.

In England, Blake proclaimed his faith in Ossian despite Wordsworth's dismissal, having already written a poem based on the plot situation of one of the 'songs'. Coleridge and Byron each versified a couple of passages. In France, the composer Jean-François Le Sueur presented a five-act opera called *Ossian, ou Les Bardes* (1804); the orchestra was supplemented (of course) by twelve harps. Many more bardic operas followed in the major cities of the Continent. Lamartine, whose 1820 volume of poems is said to have launched (or relaunched) French Romanticism, as a young man had been entranced with Ossian. Looking back on that time, he wrote:

28

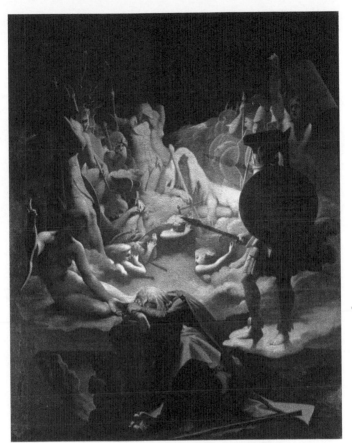

5. Jean-Auguste-Dominique Ingres, *The Dream of Ossian* (1813). Commissioned by Napoleon, who admired the Ossian poems and carried a copy of them with him on his campaigns, this oil painting shows the characters of the Ossianic songs as if they were marble or alabaster statues

Above all, Ossian, that poet of vagueness, that mist of imagination, that inarticulate lamentation of the northern seas, that foam of the strand, that moaning of the shades, that rolling of the clouds around the stormy pines of Scotland, that northern Dante, as majestic, as supernatural, as the Dante of Florence, more sensitive [*sensible*] than he, and who often wrests from his phantoms cries more human and more heart-rending than those of Homer's heroes.

François Gérard, Anne-Louis Girodet de Roussy-Triosson, and Jean-Auguste-Dominique Ingres produced major Ossianic oil paintings. The Russians accepted the idea that the Celts and Germans were the same people, and so through their own Scandinavian roots (the Rus) they thought themselves Ossian's heirs. Many translations and many more bardic poems appeared. The poet Lenski in Pushkin's *Eugene Onegin* loved to recite 'fragments of Nordic poetry'. Lermontov, of partly Scottish ancestry, celebrated his kinship in 'Ossian's Grave' (1830). And so it went, everywhere in Europe, and even the United States, where still today there are two towns called Ossian, in Indiana (population 3,000) and in Iowa (population 830). It's doubtful if anyone there but the local librarians has ever read the songs of Macpherson's bard, so remote is he from contemporary tastes, but we can scarcely understand the Romantic movement, and especially its cult of the inspired poet, unless we come to appreciate what Carlyle called 'poor moaning monotonous Macpherson'.

The old view of Romanticism as a reaction against Enlightenment rationalism in the name of emotion or the intuitions of the heart, we can now see, is misleadingly simplistic, for the Sensibility movement intervened. Indeed, that description of Romanticism would fit Sensibility rather better, or at least some if its trends. A more recent view is more interesting: that Romanticism was an episode within the larger movement of Sensibility. Certainly there is something to this idea. Wordsworth's famous formula, 'the spontaneous overflow of powerful feelings', would seem to define any personal display of emotional sensitivity better than it defines

poetry, and his portrayal of outcasts, widows, and bereaved old men in *Lyrical Ballads* seems designed to touch our pity and sympathy. So does Blake's picture of suffering children in *Songs of Innocence*, in which tears flow freely. Many a poem by Romantics in France, Germany, and Russia expresses the pain of the world and the suffering of the poet. Aeolian harps continue to tremble, and Ossianic clouds keep gathering in the literary skies.

But the Romantics also reacted against the cult of Sensibility. Some felt uneasy over the aeolian harp model, which implies that the soul is passive and helpless before external experience, or at most inspires us to turn experience into inward harmony. There was more at stake. Coleridge in 1796 wrote, 'Sensibility is not Benevolence. Nay, by making us tremblingly alive to trifling misfortunes, it frequently prevents it and induces effeminate and cowardly selfishness.' Nearly all the leading Romantic writers throughout Europe began as social or political reformers; they were virtually all inspired by the first phases of the French Revolution; to use Coleridge's word, they sought effective benevolence through renovation of government, religion, and education. They understood that melting with sympathy could be no more than a moment in one's path of commitment to social change. This is not to say that the Romantics were always effective agents of such change – far from it – but at least they took thought and took action in a sphere larger than their own hearts, the point where the earlier movement had usually stalled. The first German Romantics, who inherited the idea of *Bildung* or inner cultivation from Shaftesbury and Schiller, refused to make the heart alone its touchstone; feeling and reason are to be fused into a single faculty. The means of doing so, they thought, was art: poetry above all, but also the visual arts and music. And they saw such cultivation as a national project, even international, to be guided by an ideal of the community as an organic whole, a work of art.

Chapter 3
The poet

No characteristic of Romanticism is more prominent than the prestige, even glory, which it confers on the poet. He acquires the stature of prophet, priest, and preacher, of hero, law-giver, and creator; he grows almost into a god. 'We are on a mission', Novalis claimed in 1798: 'we are called to give shape to the earth'. 'Poets are the unacknowledged legislators of the world', P. B. Shelley wrote, in the final sentence of *A Defence of Poetry* (1821). Though these were bold statements at the time, it is a measure of the cultural distance we have travelled since then that today they strike most of us as less bold than ridiculous. We are much more likely to agree with W. H. Auden's declaration in 1939 that 'poetry makes nothing happen'. Novalis was himself dismissed by Heinrich Heine as 'powerless' because he liked to 'float enraptured in the blue ether' (*The Romantic School* [1836], 2.4), and Matthew Arnold disparaged Shelley as an 'ineffectual angel' ('Shelley' [1888]).

But before we join in mocking these grandiose Romantic claims, we should at least take note of Shelley's adjective, 'unacknowledged', for if it was characteristic of Romanticism to exalt the poet, it was equally distinctive to lament his neglect, rejection, and suffering in the modern world. It was different, they thought, in ancient Greece or in the Middle Ages, but today these great souls and saviours of the world pass through it unappreciated. The Italian poet and novelist Alessandro Manzoni,

in a sardonic mood, wrote, 'it is the fate of poets that no one ever takes their advice' (*The Betrothed* [1827], chapter 28), but usually that fate evoked gloom and grief. We should also remember that, despite the impression the Romantic poets themselves often give us, poetry was much more popular in their own day than it is now, and was taken much more seriously by a growing reading public throughout Europe, even by acknowledged legislators, some of whom wrote it themselves. Poetry was read aloud in parlours and sewing rooms, recited or sung in taverns, declaimed on state occasions, and memorized by the ream in schools. Every major public event triggered a volley of poems into the newspapers. Wordsworth, for example, seldom let pass a battle of the long war with France without sending off a sonnet, or several sonnets, whether it was the extinction of the Venetian republic, the Tyrolese resistance, or the Battle of Waterloo. Where censorship was greatest, as it was in Russia, most of the German states, and France under Napoleon III, poetry was sometimes the only outlet for social criticism, implicit and oblique though it had to be. Safely in exile on the Channel Islands after the 1851 *coup d'état* of Louis Bonaparte, Victor Hugo launched his ink bottles against 'Napoléon le Petit' with no small impact, and returned to France a hero in 1870. Some poets – real ones, not just their idealizations – played roles not unlike movie stars and talk-show hosts today, and a few of them, such as Byron, Lamartine, and Hugo himself, really were legislators in their national parliaments.

So the situation was complicated and not without its ironies and absurdities. Byron and Hugo had huge followings, and when Pushkin died, the Russian state curtailed his funeral rites lest they turn into a dangerous demonstration against it. But many poets, and artists of all sorts, filled the unheated garrets of 'Bohemia' and mocked the bourgeoisie that paid them no heed. Because poetry in general was indeed appreciated, and several poets were celebrated, it may have seemed all the more poignant that most poets suffered 'the bleak freezings of neglect', in Coleridge's phrase. If few poets today would sigh over the general public's lack of interest in their work, it is

because they have never harboured hopes for 'fame' in the full-blooded sense it still had two centuries ago. But this chapter will deal mainly with Romanticism's image, or self-image, of the poet, and only in passing with poets' real circumstances. This image still has a grip on us – the outcast genius, the consecrated soul, the prophet without honour – even though the typical poet today has little expectation of public renown, and in any case has a job at a university.

The consecrated poet

Hugo's early ode 'Le Poète' (1824) begins:

> Let him go in peace, through a world unaware of him;
> Respect his noble griefs, this grand and wretched man
>> Whom his own soul devours!
> Flee, O vain pleasures, his austere existence;
> His growing palm, jealous and solitary,
>> Cannot thrive among your flowers.

The poet's growing palm seems to be the palm of martyrdom, as the poet suffers inward griefs, but it also hints at ultimate victory, as the Christian martyrs gained heaven after enduring tortures on earth. The palm, too, towers austerely over the pretty but ephemeral flowers of pleasure. Hugo goes on to describe the poet's silent communion with the Muse and the spirits of Christ and the Prophets and then, after warning 'impudent mortals' again to stay away from him, concludes:

> A day comes when the Muse herself will send him,
> His exalted lute armed with a sacred mission,
>> Into the world that thirsts for blood,
> So he, to rescue us from our own rashness,
> May bring down from on high to threatening man
>> The prayer of Almighty God.

> A formidable spirit comes into his thought.
> He appears, and suddenly, his words in flashes
>> Shine like a burning bough.

> The people crowd around him, prostrate at his feet;
>
> Mysterious Sinai and its lightnings crown him,
>
> A very God is on his brow.

This is the wishful daydream of the youthful Hugo, no doubt, but its audacity is breathtaking, and some readers thrilled to it. The unacknowledged communer with spirits becomes the luminous legislator of the world, a second Moses. Moses, in fact, appears in Shelley's list of 'poets' in the *Defence*. Alfred de Vigny's poem 'Moïse' ('Moses'), written in 1822, portrays him in his final moments, still isolated from his people by the mission God has called him to, as he sees the promised land he will not live to enter. Vigny later wrote that Moses stands for 'the man of genius, weary of his eternal widowerhood and in despair at seeing his solitude grow ever more immense and arid as his grandeur grows'.

Pushkin, speaking in the first person in 'Prorok' ('The Prophet', 1826), tells how a six-winged seraph laid his fingers upon the poet's weary eyes, 'and like an eagle's in amaze / They opened with all-seeing gaze.' After more transfigurations, the poet, now a prophet, is sent forth into the world with the command, 'Burn with my Word the heart of man' (tr. Antony Wood). Coleridge concludes his mysterious and musical 'Kubla Khan' (1798) with a vision of a muse whose song, if he could revive it, would lead all who heard him sing it to cry

> Beware! Beware!
>
> His flashing eyes, his floating hair!
>
> Weave a circle round him thrice,
>
> And close your eyes with holy dread,
>
> For he on honeydew hath fed,
>
> And drunk the milk of Paradise.

With the exception of Shelley's statement, these descriptions all borrow heavily from religious categories. Coleridge's has a pagan aura, but the final word is 'Paradise'. Even Shelley, in the preceding sentence, claims that 'Poets are the hierophants of an unapprehended inspiration', hierophants being Greek priests or

35

revealers of the mysteries. We seem to be witnessing a kind of usurpation of the Christian altar and pulpit by lay poets, some Christian, some not, and it seems to have been welcomed by a growing portion of the reading public in most European lands that had become, if not exactly irreligious, then at least detached from particular churches and doctrines, while remaining responsive to a kind of religious mood or feeling. (We shall turn later to Romanticism as a religious movement.)

Many 18th-century readers shared Thomas Gray's view that after John Milton (1608–74), author of *Paradise Lost*, who 'rode sublime / Upon the seraph-wings of ecstasy', or at least after '[John] Dryden's less presumptuous car [chariot]', no great poet had appeared in England: 'Oh! lyre divine, what daring spirit / Wakes thee now?' ('The Progress of Poesy', 1757). It is not just in retrospect, after the explosion of lyric poetry that marks the onset of Romanticism, that much of the 18th century looks 'pre-Romantic', like a period of anticipation, preparation, perhaps incubation, of the coming Great Poet, quiet on the surface but with premonitory rumblings beneath, for to many in England, France, and Germany, it looked like it at the time. It was certainly an era when poets themselves, not only Gray, but Akenside in 'On Lyric Poetry' (1745) and Collins in his 'Ode on the Poetical Character' (1746), celebrated the genius and sacred vocation of their brother poets and wondered when the next Milton would arrive. In one of his earliest odes, 'The Apprentice of the Greeks' (1747), Klopstock imagines a young poet to come who will refuse the pride of the warrior and the glory of the battlefield in the name of something higher:

> Tears for a greater glory will make him companion
> Of those ancient immortal ones
> Whose everlasting worth, like swelling rivers,
> Widens through every long century,
> And will consecrate him with those honors
> The proud one only dreams about!

It is not surprising, in light of this expectation, that several poets of the Romantic generations not only felt called and consecrated but made their vocation the subject of much of their poetry. Wordsworth devoted his greatest and longest work, begun in 1799 but only published in the year of his death (1850) under the title *The Prelude*, to the story of his life, and especially of those experiences that shaped him and confirmed him as a poet. The poem, in thirteen (later revised to fourteen) books, addressed to his fellow poet Coleridge, and written in blank verse that sometimes achieves Milton's sublimity, is implicitly the main evidence in its own case, but Wordsworth is not shy in explicitly claiming his place among the visionary or prophetic poets: 'it shall be my pride / That I have dared to tread this holy ground, / Speaking no dream but things oracular.' He goes on to confess the hope

> That unto me had also been vouchsafed
> An influx, that in some sort I possess'd
> A privilege, and that a work of mine,
> Proceeding from the depth of untaught things,
> Enduring and creative, might become
> A power like one of Nature's.

<div align="center">(1805, Prelude, 12.250–2, 307–12)</div>

He concludes this spiritual autobiography by envisaging the day when, after men 'fall back to old idolatry', he and Coleridge will be joint-labourers in 'a work ... Of their redemption':

> Prophets of Nature, we to them will speak
> A lasting inspiration, sanctified
> By reason and by truth; what we have loved,
> Others will love; and we may teach them how[.]

<div align="center">(13.432–45)</div>

Coleridge himself, in his poem 'To Wordsworth' (1807), written the night after hearing Wordsworth recite *The Prelude*, calls it a 'prophetic Lay' and 'a sacred Roll'; when it was finished, 'I found

<div align="right">The poet</div>

myself in Prayer!' Twenty years later, Felicia Hemans calls
Wordsworth a 'True bard and holy!' ('To Wordsworth', 1828).

Friedrich Hölderlin asks the question Gray asked, 'Where are poets
now like our old ones?' And he answers that Urania, the highest
Muse (and the one Milton invoked), who now hangs back in
silence, plans 'a joyful work', 'a new formation', that shall reflect the
spirit of the German people ('The German's Song', 1799). In 'The
Poet's Vocation' (1800–1), he describes how his poetic calling came
upon him –

> . . . O all you heavenly gods
>> And all you streams and shores, hilltops and woods,
>>> Where first, when by the hair one of you
>>>> Seized us and the unhoped-for spirit
>
> Unforgettably came, astonishing, down
>> Upon us, godlike and creative, dumbfounding
>>> The mind, every bone shook
>>>> As if struck by lightning –

and how he will confront with this spirit the state of things
that Wordsworth calls 'old idolatry', where 'Heavenly powers
[are] trifled away, mercies / Squandered for sport, thankless,
a / Generation of schemers' (tr. Middleton).

Lamartine, too, is seized by a god, 'Enthusiasm', which has
swooped down on him like an eagle:

> At the sound of your fiery wings
> I tremble with a holy dread;
> I struggle under your power,
> I flee, I fear lest your presence
> Will annihilate a mortal soul,
> Like an inextinguishable fire
> Lit by lightning, that burns up
> The pyre, the altar, and the temple.

> ('Enthusiasm', 1820)

This seizure leaves him exhausted and almost in despair, but his sense of mission remained strong. Within a year, Lamartine felt he had received a heavenly directive to write a grand epic of humanity. When he learned he might possibly have Arabic blood, he made it a sign of his messianic destiny. All true poets, he believed, could read a 'sublime language' in nature, once known to all men but now remembered only by the priesthood of poets, whose task was to communicate with God through this language and interpret both God and nature to the multitude. When the multitude chose Lamartine to be the leader of the provisional republic in 1848, they confirmed what heaven had announced to him decades before.

Eagles

Pushkin, as we saw, likens himself to a young eagle opening its eyes, and Lamartine feels seized by an eagle, indeed like Ganymede, rapt up to Olympus by Zeus's bird. These two images express two distinct concepts of genius – Pushkin's the sovereign master of his art and Lamartine's the ecstatic servant of the muses or the gods; each has ancient precedents, and each was common in Romanticism's picture of itself. That both Pushkin and Lamartine use eagle metaphors, however, is in some ways an even more revealing characteristic of that picture, and rather surprising.

Since the Greeks, poets have been nightingales: Hesiod called himself a nightingale, and Theocritus called Homer the 'Chian nightingale' (after Chios, the island thought to be Homer's birthplace). The lovelorn bird sang through the lovelorn songs of the Provençal troubadours and German Minnesängers. Milton compared himself to one, for he sang in the dark. Keats's bird, the most famous in English, sings in full-throated ease while Keats listens, trying not to be envious ('Ode to a Nightingale', 1819). In Russia, on the verge of Romanticism, Derzhavin calls on his follow poet, 'Sing Karamzin! – Even in prose the voice of the

nightingale is heard' ('A Stroll in Tsarskoe Selo', 1791), while Karamzin, in 'The Nightingale, Jackdaws and Ravens' (1793), complains that the nightingale has lost her place in the forest, drowned out by the harsh cries of jackdaws and ravens.

Or poets have been swans. Horace called Pindar the 'swan of Dirce', and thereby launched two millennia of clichés whereby Shakespeare is the Swan of Avon and every other poet is the swan of some river or other. Swans supposedly sing at their death, so the 'swan song' became another cliché after Ovid declared the final book of his *Tristia*, written in his lonely exile by the Black Sea, to be the sad song of a swan. Then there is the lark, which flew into poetry during the Middle Ages and has been pouring its heart out ever since. Wordsworth wrote two skylark poems, while Shelley's 'To a Sky-Lark' (1820), in which he compares the little bird to a 'Poet hidden / In the light of thought', is as well known as Keats's 'Ode to a Nightingale'. Eichendorff identifies intensely with the mounting, gliding, and soaring of the bird in 'The Lark' (1818); the Hungarian poet Petöfi hears a skylark after a battle and is reminded that he is a poet first and soldier second ('The skylark sings...', 1849). Even the cuckoo joins the chorus of bird-bards; it was a favourite of Wordsworth.

All these birds chirp and chant through Romantic poetry, just as we would expect, but they are almost overshadowed by the arrival of the eagle. Nothing much had been heard from eagles as poets since Pindar compared himself to one, and then Dante called Homer an eagle in the *Inferno*, but in his 'Progress of Poetry' (1754) Gray names Pindar 'the Theban eagle', 'sailing with supreme dominion / Through the azure deep of air', and thus gave an impetus to its return. James Beattie praises Gray himself as a second eagle-Pindar: 'sublime, on eagle-pinion driven, / He soars Pindaric heights, and sails the waste of heaven' ('On the Report of a Monument', 1766). Klopstock, in 'Thuiskon' (1764), contrasts the swan of Horace with 'the varying, bolder, and more German flight of an ode, / Which like the eagle now mounts to the clouds, / And

then drops down to the top branches of the oak.' So the new German ode will outfly the old neoclassical model, as Pindar soars above Horace. Shelley too takes an aquiline flight:

> My soul spurned the chains of its dismay,
> And in the rapid plumes of song
> Clothed itself, sublime and strong;
> As a young eagle soars the morning clouds among,
> Hovering in verse o'er its accustomed prey.

> ('Ode to Liberty', 1820)

The 'prey' here must be the subject matter of his verse.

If that metaphor seems forced, more than one French poet worked the image for every weird implication. Here is Lamartine, near the beginning of his long poem addressed to Byron (1820):

> The eagle, king of the wilderness, thus scorns the plain;
> He wants, like you, only steep and rocky heights
> That winter has whitened, that lightning has struck,
> Shores covered with the debris of shipwrecks,
> Or fields all blackened with the remnants of carnage:
> And, while the bird that sings its sorrows
> Builds at water's edge its nest among the flowers,
> That one clears the horrible peak of the summits of Athos,
> On the mountainsides hangs his eyrie over the abyss,
> And there, alone, surrounded by throbbing limbs,
> By rocks dripping incessantly with blood,
> Taking pleasure in the cries of his prey,
> Soothed by the tempest, he falls asleep in joy.

Like Klopstock, Lamartine contrasts 'the bird that sings its sorrows', the swan, that is, Lamartine himself, with the bird that wreaks sorrow all around him, the eagle, Byron. Hugo constructs an entire poem, 'To my Friend S-B [Sainte-Beuve]' (1828), on the eagle image: the eagle is 'genius', its prey is what it writes about, and the young eaglets in the nest must be readers, or perhaps future poets, little fledgling Hugos:

Royal nest! Dark palace, to which the rolling, leaping
Avalanche of a flood of snow lays siege!
Genius nurtures its children there with love,
And turning toward the sun their eyes filled with flames,
Under its wing of fire incubates young souls
Who will put on wings one day!

In 'Heimkunft' ('Homecoming', 1800–1), Hölderlin notes: 'Yet the
bird of thunder marks the time, and between / Peaks, high in the
air, hangs and summons the day' (11–12; tr. Hamburger). Here
the eagle is an analogue for the poet, who in this very poem is
proclaiming the coming of the god and the dawning of a new day.
An eagle in 'Germanien' (1799–1803) flies from the Indus to
Greece and Italy (42 ff). In the fragmentary 'Der Adler' ('The
Eagle') (1800–5), the parents of the eagle, who seems to be the
speaker, came 'out of the forests of the Indus' (10), where Hölderlin
believed Dionysus, the god of poets, originated.

These are a few of many symbolic eagles that gather in the skies of
European poetry in the late 18th century, flock thickly till about
1850, and then thin out and become rare birds by century's end.
It is all rather surprising when one remembers that the eagle is not
a songbird. The nightingale, the lark, the cuckoo, and even the
swan, supposedly, when it dies, sing like poets; the eagle is more
likely to eat one of these birds than sing like it. The eagle is the king
of birds, the companion of Zeus, the greatest raptor, the highest
soarer, and it is capable, according to ancient tradition, of staring
into the sun without being blinded. It is all rather grandiose, even
absurd: who are these upstart larks and other songsters, now
claiming to be aristocrats, lords of the sky? They're just poets!
But that was just the point, and so the eagle, as a symbol for genius,
the poet, or poetic enthusiasm, became a striking and
distinctively Romantic emblem.

A few Romantic eagles, however, found themselves ill, or wounded,
or caged. Annette von Droste-Hülshoff imagines an eagle with

broken wings, but with a spirit that would rather be an eagle with broken wings than a chicken living comfortably near a warm stove ('The Ailing Eagle'). She is echoing Goethe's early poem, 'Eagle and Dove' (1773), an allegory about two types of poetry, where a young eagle, wounded by a hunter as it made for its prey and now unable to fly, is consoled by a well-meaning dove that points out all the nice things to eat on the ground and in the bushes. 'O Wisdom!' the eagle answers, 'You speak like a dove!' Keats feels like a 'sick eagle' on seeing the Elgin marbles. Felicia Hemans's 'The Wounded Eagle' is one long simile for the destiny of 'gifted souls and high'. The usual power and prowess of the eagle nonetheless put limits on its use as a symbol of the suffering poet. To that important, almost obsessive, theme, the Romantics chose a more literal approach.

Dying poets

It is still a commonplace about the Romantic poet or artist that he dies young, preferably of tuberculosis, or suicide, or a duel, or starvation in a garret, or in exile. In the English-speaking world, the 'second generation' of poets – Keats, Shelley, and Byron – have engraved that pattern deeply on our minds, even though the first generation – Blake, Wordsworth, and Coleridge – lived long lives. Keats died of tuberculosis in Rome at 25, Shelley drowned in the Bay of Lerici at 29, and Byron died of fever in Greece at 36. Pushkin died of wounds from a duel at 37. Karoline von Günderrode, rejected by the man she loved, shot herself in the heart at 26. But the Romantics themselves had already worshipped at the shrines of poets who died young.

One French poet, nearly forgotten today, Charles Loyson (1791–1820), wrote 'The Young Poet on his Death Bed' (1819) a year before his own untimely death, and thereby swelled a French vogue for dying-poet poems. But he deserves to be remembered for something else. As Sainte-Beuve wrote in an essay of 1840, Loyson had a chateau in Spain with an enclosed grove.

The poet

43

In the most secluded part of the grove, he has dedicated a little
cluster of cypresses, birches, and evergreens to young writers
dead before their time. The details of its execution are ravishing.
A funerary urn, placed on a mound of grass, bears the name
Tibullus, and on the bark of the nearby birch we read these two
verses of Domitius Marsus:

> Te quoque Virgilio comitem non aequa, Tibulle,
> Mors juvenem campos misit ad Elysios.
> [You, too, Tibullus, Virgil's friend, unfair death
> Sent in youth to the Elysian field.]

At a little distance, a pyramid of black marble between the yews invokes
the memory of Lucan, dead at twenty-six years, whom one wants to
think the victim of the audacity of his muse, and perhaps the poetic
jealousy of the tyrant; there we read these verses of the *Pharsalia*:

> Me solum invadite ferro,
> Me frustra leges et inania jura tuentem.
> [... Attack me alone with your sword,
> Me the guardian of vain laws and empty rights. (2.315–16)]

Two doves under a weeping willow represent the *Kisses* of Jean
Second, dead before his twenty-fifth year. We see the idea; it is
followed and varied to the end. Malfilâtre and Gilbert are not left out;
we greet their marbles. An overturned basket of flowers provides the
emblem of the fate of Millevoye, fallen the day before. Chatterton,
who killed himself, has only a naked rock. André Chénier is
encountered in turn and has one of the most beautiful places. Thus
Loyson had a presentiment of his own end, and populated
beforehand with a cherished group the secret grove of his Elysium.

Loyson had translated many poems by Tibullus, who was honoured
by one of the great elegies of the ancient world, Ovid's *Amores* 3.9.
In that lament, Ovid makes the claim that bards are sacred and the
concern of the gods, and he imagines Tibullus in 'the vale of Elysium'
with other poets, as if in Loyson's grove. Lucan, whose *Pharsalia* is
thought to be the greatest Latin epic after Virgil's, was compelled to

commit suicide by Nero. In Shelley's 'Adonais', his elegy on the death of Keats, several dead poets, 'inheritors of unfulfilled renown', rise to welcome Keats; one of them is 'Lucan, by his death approved'. Jean Second was Janus Secundus (Jan Everaerts), a 16th-century Dutch poet writing in Latin; his 'Kisses' are mainly imitations of Catullus. The next three are French poets, all of whom died of injuries. Thomas Chatterton, he of the naked rock, we will turn to shortly. André Chénier, whose poems were rediscovered in 1819 just as Romanticism was relaunched, was guillotined during the Terror in 1794, just a few days before the Terror was itself overthrown. The largest section of Vigny's novel *Stello* (1832) is devoted to Chénier (the other two are about Chatterton and Gilbert), and Pushkin wrote a poem about him in 1826.

Loyson was only the most ambitious in promoting this cult of young poets, as he recreated the Elysian Fields in his back yard; all of his heroes and several others may be found in many French poems. Thomas Chatterton was the most celebrated of the lot; he certainly died the youngest, when his precocious genius, though shadowed by fraud, seemed just about to soar. Born in 1752 in Bristol, as a boy he haunted the church of St Mary Redcliffe and read Chaucer, Spenser, and the antiquarians. By the time he was 12, he was forging poems in archaic English and passing them off as medieval. Moving to London in 1770, his 'Rowley' poems, which he attributed to a 15th-century monk named Thomas Rowley, were noticed and admired. His finances were precarious, and he might soon have been exposed as a forger – for these or perhaps other reasons, he seems to have committed suicide by poison. He was 17.

When he was barely a year older than Chatterton at his death, Coleridge wrote a 'Monody on the Death of Chatterton' (c. 1790), in which he blames 'Want and cold Neglect' for the boy's tragic fate, as well as 'the keen insult of th'unfeeling Heart, / The dread dependence on the low-born mind', the mind of the public and publishers, it would seem, too dull to recognize his genius. But he is now a 'Spirit blest', pouring forth his hymn among the Cherubim,

'Or, soaring through the blest Domain, / Enraptur'st Angels with thy strain.' When Coleridge and his friend Southey married the two Fricker sisters, the wedding ceremony took place in St Mary Redcliffe Church.

In 'Resolution and Independence', written in 1802, Wordsworth reports his bleak thoughts while walking on a moor:

> I thought of Chatterton, the marvellous Boy,
> The sleepless Soul that perished in its pride;
> Of Him who walked in glory and in joy
> Behind his plough, upon the mountain-side [Robert Burns,
> dead at thirty-seven]:
> By our own spirits are we deified;
> We Poets in our youth begin in gladness,
> But thereof comes in the end despondency and madness.

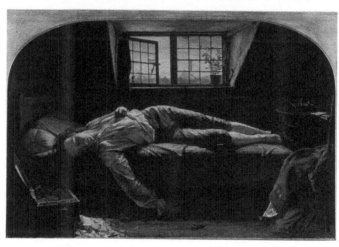

6. Henry Wallis, *The Death of Chatterton* (1856). When it was first exhibited, the painting was accompanied by these lines from Marlowe's *Doctor Faustus*: 'Cut is the branch that might have grown full straight / And burned is Apollo's laurel bough.' The model for the dead Chatterton was the novelist George Meredith, then about 28

Mary Robinson, like Coleridge, wrote a 'Monody to the Memory of Chatterton' (1806) that wrings as much pathos as possible from his poverty and neglect. She makes him a flower, nipped in the bud: 'So the pale primrose, sweetest bud of May, / Scarce wakes to beauty ere it feels decay.' Keats delighted in reading Chatterton's verse aloud, and felt, as well he might, a kinship with his story of budding promise blasted. 'Thou didst die / A half-blown flower', Keats writes, in one of his first sonnets, 'Oh Chatterton!' (1815), but, like Coleridge and Robinson, Keats places him in heaven, where 'to the rolling spheres / Thou sweetly singest.' Three years later, Keats dedicated to Chatterton his first effort at an epic poem, *Endymion*. William Henry Ireland produced a set of poems called *Neglected Genius* (1812), one poem each on the greatness and suffering of Spenser, Milton, Dryden, Thomson, Goldsmith, and several others, concluding with Chatterton:

> Great *Chatterton* awakes my pensive song,
> Sublimest stripling of the muse's throng;
> Prolific prodigy of fancy's womb,
> Born but to blaze, then moulder in the tomb.

These lines may reveal why William Henry Ireland's own genius has been neglected, but they deserve notice for their digesting and disgorging of poor Tom Chatterton as an icon, performed with less talent than Coleridge or Keats, perhaps, but no more caught up in the Chatterton cult than they. It is as if all these poems (and there were many more) were votive candles lit at a shrine to ward off despondency and madness, or perhaps warning shots fired across the bows of hard-hearted critics.

Suffering poets

If 'neglected genius' is a larger category than 'poets dying young', larger still, alas, is 'suffering poets', neglected or not, and in poem after poem, play after play, the Romantics summoned their spirits to cheer themselves or their contemporaries. Ugo Foscolo single-handedly turned the difficult life of Giuseppe Parini, whose sharp

satires of the nobility brought trouble on his head, into a legend; he devotes a vivid section of his greatest poem, 'On Sepulchers' (1807), to the outrage done to Parini's body as it was tossed into a common grave. Lamartine dedicated 'La Gloire' ('Glory', 1820) to a long-lived but recently deceased poet exiled from Portugal, Francisco Manoel do Nascimento (1734–1819). In it, he invokes Homer:

> Here an old man whom ungrateful Ionia
> Saw taking his miseries from sea to sea,
> Blind, would beg as the price of his genius
> Bread moistened with tears.

Then Tasso:

> There Tasso, burning with a fatal flame,
> Atoning in irons for his glory and love,
> When about to collect his triumphal palm,
> Descends to the darkness.

Then the generals Aristides, ostracized by Athens, and Coriolanus, exiled by Rome. And then, in the final stanza, Ovid, banished to Tomis on the Black Sea.

> Before descending to the shores of the dead,
> Ovid raises to heaven his suppliant hands:
> To the rude Sarmatians he bequeathed his ashes,
> To the Romans his glory.

Legend tells that Torquato Tasso (1544–95), the great Italian poet, author of the epic *Jerusalem Liberated* and many sonnets, fell in love with Leonora, the sister of the Duke of Ferrara, and was confined as a madman for seven years. After Tasso's release, Pope Clement VIII planned to crown him poet laureate at the Capitol, but the poet died before the ceremony. Illicit love, madness, the cruelty of a tyrant, genius recognized too late – this was irresistible Romantic material. Goethe launched the Tasso vogue with his play *Torquato Tasso* (1790), which Mme de Staël analysed in her influential book *De L'Allemagne* (*On Germany*). Byron wrote about Tasso both in *Childe Harold* Canto 4 and in 'The Lament of Tasso'

(both 1817), the latter a long epistle to Leonora in which the poet, the 'eagle-spirit of a Child of Song', bemoans his long captivity but takes some consolation in knowing that, when the castle of Ferrara has crumbled, 'A poet's wreath shall be thine only crown, / A poet's dungeon thy most far renown.' Shelley planned a play on Tasso and wrote a scene and song for it (1818), while Felicia Hemans wrote 'The Release of Tasso' (1823) and 'Tasso and his Sister' (1826), the latter drawing from Staël's *Corinne*. In Russia, Batyushkov composed 'The Dying Tasso' (1817). Lamartine returned to Tasso in several other poems, and late in life he wrote in his memoirs of a state of nervous collapse he suffered in Naples in early 1821, brought on by reading a life of Tasso and thinking about his madness. Delacroix painted several versions of *Tasso in the Madhouse* and a *Tasso in Prison* in the 1820s and 1830s. Donizetti made an opera out of the story in 1833, and Liszt composed a symphonic poem called *Tasso* in 1849. The locales of Tasso's unhappy life became shrines. Shelley visited Ferrara in 1818, as Byron had the year before, and went to see the cell where Tasso languished. Berlioz and Mendelssohn visited Tasso's tomb together in Rome in 1831.

Ovid, the poet of the *Metamorphoses* (as well as the elegy to Tibullus), had offended Caesar Augustus, perhaps through some of his poems, and was exiled to a lonely Roman outpost on the Black Sea (Pontos), surrounded by 'Scythians' or 'Sarmatians'. He sent many poems to friends in Rome, poems gathered in the *Tristia* (*Sorrows*) and *Ex Ponto*, but they failed to obtain his pardon, and he died in exile. In one of the *Tristia* (3.7), he solaces himself with the thought that his fame as a poet would survive his death: 'So long as from her seven hills victorious / Rome scans the conquered world, I shall be read' (tr. Melville). Pushkin, during his own exile from St Petersburg for offending his own Caesar, visited Tomis and remembered these lines, which were more prophetic than Ovid had hoped. His fame had survived even the death of Rome! But Pushkin himself would be lost in the crowd, doomed to soundlessness, chanting to no one in a barbarous tongue

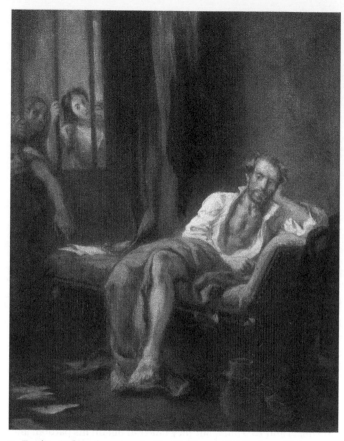

7. Eugène Delacroix, *Tasso in the Madhouse* (1839). One of his visitors points to Tasso's writings, mainly scattered on the floor, as if to recall him to his poetic mission, but Tasso remains lost in the contemplation of his wrongs

('To Ovid', 1821). In Austria, Franz Grillparzer, though not in exile like Pushkin, wrote 'Tristia ex Ponto' (begun in 1826), a cycle of poems about despair and artistic sterility. Delacroix was drawn to this subject, too, as he was to Tasso in captivity, twice painting an *Ovid among the Scythians*.

It is interesting to note how many major Romantic poets were exiles, either for political reasons or because they found their homeland stifling and ungrateful. Pushkin served terms banished to the Crimea or confined to his country estate. Lermontov spent a year exiled to the Caucasus. The Polish poet Adam Mickiewicz was arrested and then exiled to Russia, though he was free to travel there; he never saw Warsaw. The Italian poet Ugo Foscolo, born on the Greek island of Zakynthos, then under Venetian control, fled Venice because of his liberal political views; later he fled Milan for the same reason; after a time in Switzerland, he emigrated to England, where he remained until his death. Victor Hugo spent twenty years on the islands of Jersey and Guernsey waiting for the regime of Napoleon III to fall. Both Byron and Shelley fled England for the 'paradise of exiles', Italy (though it was not a paradise for Foscolo). Heine left Germany for Paris. Whether we could find commonalities in these poets because of their flights is not certain, for their circumstances varied as much as their characters, but it is a theme that deserves investigation. For one thing, the travels of the poets from land to land helped make Romanticism an international movement. All these poets could speak two or three languages and read several more. Mickiewicz lectured on Slavic literature in Paris, where Heine was writing about German literature; Foscolo wrote on Italian literature in London. But the exiles also seemed to embody the theme we have explored in this chapter, the prophet without honour in his homeland, the soul withdrawn from society because he speaks a strange language. It had a great future, this image of the outcast, suffering, or insane poet: in France, for example, with the extravagant lives of Rimbaud and Verlaine in the 1870s, and in America nearly a century later, with the constant restlessness and drug-induced visions of Kerouac, Ginsberg, and the other Beatniks.

A cynic might detect in all these exorbitant claims about the grandeur and misery of poets a transparent plea by Romantic poets for more respect and better sales, the propaganda of their guild.

There is indeed some truth in this idea, as Romanticism was in part a response to the transition from patronage to public book-purchasing as the chief means of poets' support. To please a lord, or round up subscriptions to a pricey volume, usually required modesty and good manners, while to rouse the interest of the book-buying middle classes seemed to call for something bolder, even shocking. Bad publicity is still publicity, as the scandalous Byron knew. Satire, a staple of poetry during the age of patronage, may have been risky, but because the patrons themselves fell into factions, skill at satire was also a meal-ticket for their hatchet-men. Great claims to be a prophet or even a legislator, on the other hand, were not likely to win much aristocratic support, though of course there were exceptions. Nightingales were all very well, but to pretend to be eagles was as preposterous as to pretend to be lords.

Widening meanings

Of course, there is good deal more to Romanticism than the apotheosis of the poet, or it might not have gained purchase much beyond a few circles of poets and artists. For Romanticism became immensely popular, not only its poetry but its literature of every kind, its painting, its music, its opera, even its ballet. The ten thousand people who bought Byron's *The Corsair* on the day it appeared in 1814 were not all poets, or would-be poets, nor were the one million people who watched Victor Hugo's funeral procession in 1885. Between those dates, crowds filled the auditoriums to hear Chopin or Paganini, or the salons to see Delacroix. Practically every longer work by Schiller, Scott, Byron, Hugo, and Pushkin became an opera, or several operas, not to mention, as we have seen, Ossian. Operas were expensive to mount; they would not have been mounted without audiences willing to pay.

Still, even though pirates and giaours and medieval lovers and all the other subjects of Romantic literature and art gave it much of its popularity, the theme of the special gift and burden of the poet

touched large numbers of people who never harboured aspirations to become one. The poet, alongside other outcasts such as pirates and giaours and just lonely sensitive souls, was easy to identify within an age that increasingly felt 'the world is too much with us', in Wordsworth's famous phrase, that 'getting and spending', making a living in an increasingly complex and regimented and urbanized society, was draining us of life and hope, of meaningfulness, of our very capacity to feel. Readers could project onto the poet and his soulful brethren the anxiety and loss they felt in their own lives, while turning to him, as in an earlier age they might have turned to their vicar or schoolmaster, for guidance through this difficult world, which seemed infected by the old idolatry while changing faster than it ever had.

It probably also helped Romanticism's appeal that, even while offering an image of the consecrated creative artist, who after all was rare, it also tended to democratize the creative spirit. It gave the impression that anyone could be a poet, if one could break free of conventional thinking, reawaken one's dreams, revive one's buried childhood, and expand one's imagination. While the great poets were in fact masters of their craft, learned in the history of poetry in several languages, they often spoke as if poetry just happened to them, as the 'spontaneous overflow of powerful feelings', in Wordsworth's phrase, or as the vibrations of an aeolian harp in response to an inspirational breeze.

It was part of this opening, this deprofessionalizing of the poet, that the term was widened to include much more than a writer of verse. In Shelley's *Defence*, 'poets' included 'the great historians', prophets, teachers, and even 'the instituters of laws' themselves, such as Moses. Such a generous, if still exalted, definition of 'poet' and 'poetry' is characteristic of Romanticism and belongs high on our list of its family traits. The Schlegels and others in their circle routinely called 'poetry' the prose they most admired, notably Goethe's novel *Wilhelm Meister*, and even extended it to the nonverbal arts, as Diderot had called some paintings 'poetic' in his

reviews of the Paris salons of the 1770s. Coleridge agreed that a poem need not have metre, that is, it could be great prose. Vigny called *Ivanhoe* a poem, and Rimbaud called Hugo's *Les Misérables* a poem. Gogol wrote 'Poem' on the title page of his novel *Dead Souls*. In his music criticism, Tieck called absolute music 'poetic', and Berlioz called Beethoven's *Pastoral Symphony* a poem. Sometimes the terms were widened to refer to a deep metaphysical force. Hearkening to its original Greek sense, as Shelley did (*poiein* means 'to make'), the philosopher Schelling used *Poesie* to mean the unconscious power of creativity in both man and nature. Even God is a Poet, who made the world through verbal commands and the naming of things; nature is his poem. Lammenais wrote, 'Poetry is Art itself, or Beauty incarnate, clothed in a perceptible form. Thus the universe is a great poem, God's poem, which we endeavor to reproduce in ours.' Shelley quotes Tasso with approval: 'None deserves the name of creator except God and the Poet.'

It might seem that, if God is a poet, then very few of us deserve the name, but it was also characteristic of Romanticism, as we shall see in a later chapter, to claim that God is immanent rather than (or more than) transcendent, that he dwells in nature and in us, and perhaps only there, or that he is incomplete without our hearts and minds. Most Romantics believed that the imagination was the supreme human faculty, superior to reason or understanding, and when it was fully exercised humans achieved a godlike vision and creative power. For Coleridge, as he lays it out in his *Biographia Literaria* (1817), the imagination is a mediating and unifying power of the mind: it unites the other faculties and unites the mind itself with nature. It is creative, and 'poetic'. In contrast to the fancy, which superficially aggregates given perceptions, the imagination produces something new, by a deeper kind of diffusion and refusion through symbols. It is 'esemplastic', in Coleridge's Greekish misprision of the German *Einbildungskraft* ('power of imagination'); that is, it shapes things into one. What it creates, or 'half-creates' (as Wordsworth puts it in 'Tintern Abbey'),

is not imaginary but imaginative; indeed, the difference between those adjectives bespeaks the value Romantic thinkers ascribed to the imagination. Its products are not arbitrary concoctions, however witty or 'original'; it gives us the power (again in Wordsworth's phrase) to 'see into the life of things'. Coleridge was drawing on the Germans Tetens, Kant, Schelling, and others, who had been arguing for wider and deeper creative faculty than the one they took from British empiricism, in large part to overcome what they took to be the inadequacies of the empiricist view of the mind's relationship to the world. The imagination was not a blank slate, not just the passive power to register, remember, and compare perceptions or 'images', but an active power to shape the perceptions themselves in fundamental ways. And everyone had it. Everyone could go for a walk in the woods and feel enraptured over a nightingale's song or moved to a sublime state on approaching a waterfall. Whether they ever put pen to paper, they could feel at one with nature, with God in nature, with the ancient gods of nature, with human beings at their best, and with the poets who so beautifully sang about these feelings. Wordsworth imagines his brother, a sailor at sea, as a 'silent Poet' because of his 'watchful heart' and trained eye and ear ('When, to the attractions of the busy world'). And everyone could feel alienated and lonely, or beset by a cold and selfish world, and identify all the more with the poet who felt so eloquently the same way. The seeds of Walt Whitman's 'democratic poetry' are planted here.

Women poets

Though we have quoted or cited several women poets, the prevalent assumption about poets, even in some of the poems by these same women, is that they are men. But of course, they were not all men, and many of the women poets projected an image of the female poet, or 'poetess', that differed in salient ways from that of the male. First of all, and not surprisingly, women poets were more modest about their genius or sacred calling: if they identified with eagles, it was, as we have seen in Hemans and

Droste-Hülshoff, with eagles that are caged or injured. Sometimes they express frustration at their failure to soar to the heights, and sometimes a gentle disdain for such soaring. Amable Tastu, for instance, with a touch of irony, acknowledges in her poem 'To M. Victor Hugo' (1826) that there are indeed (male) poetic eagles, but she is not among them.

> Sometimes, deluded with a distant dream,
> I have longed to attempt that lofty realm
> Where our eagles, gathered in an azure sky,
> Trace widening circles with fearless wing;
> But my hesitant wing, when it tries to fly,
> Cannot close its curve without wavering;
> My flight always tends toward its earthly home,
> And at day's bright light I lower my eye.

A similar down-to-earth stance is taken by Günderode, in a poem written not long before her suicide in 1806, 'Der Luftschiffer' ('The Balloonist'). It reads as if it is a reply in advance to a remark of Goethe's in *Poetry and Truth* (1811–33):

> True poetry proclaims itself as a secular gospel in its ability to liberate us from the earthly burdens that oppress us by producing in us serenity and a physical sense of well-being. It lifts us and our ballast into higher spheres like a balloon, leaving the confused and labyrinthine path of our earthly meanderings below us in a bird's-eye perspective.

> (tr. Catherine Hutter)

Günderode sails in her poetic and meditative airship almost into the heavens, and drinks 'the ether of eternity',

> But alas! I am pulled down,
> My view the mist enshrouds,
> The bounds of earth I see again,
> And am driven back by clouds.
> Woe! Gravity's stern law

Reasserts its case:
No one may withdraw
From the earthbound race.

Several women poets recycled the classic modesty topos of Horace in his ode *Pindarum quisquis studet aemulari* ('Whoever tries to compete with Pindar') (*Odes* 4.2), where the poet praises the inimitable Pindar as a swan lifted by a mighty wind and then describes himself as a mere bee 'laboriously harvesting thyme from numerous groves and banks' and quietly making intricate poems. A poem Caroline Bowles (later Southey) included in her novel *Ellen Fitzarthur* (1820) begins:

Parnassus! to thy heights sublime,
Thy awful steep, I may not climb
Where rays of living light surround
Thy sacred fane, with laurels crowned,
And gushes with melodious flow
Thy fountain, from its source below.

I may not look with eagle gaze
Unshrinking, on those living rays;
I may not soar on eagle's wing,
To drink of that celestial spring[.]

Instead, the poet is content to haunt the vale below, catch a distant glimpse of the mount, and weave a chaplet of wildflowers. Her poem is governed less by Horace's irony than by sorrow, however, as she goes on to lament the loss of one who would have listened to her song. A more closely Horatian note is struck by the Spanish poet Carolina Coronado, in a sonnet 'To my uncle Don Pedro Romero' (1843). Convinced that her 'girl's voice' would fail at singing great national and moral themes, she concludes: 'I would rather, as a humble bee, here on the earth / Fly forever unnoticed from flower to flower, / Than following the enraptured [*arrebatada*] eagle / Mount in flight again with short wings.'

The thought of home with its duties and blessings, the wish to shun the glare of public renown and flourish in the light only of husband or family, these usually win out over the desire to join the ranks of the poets shining in the heaven of fame. The very fact that so many poems proclaiming the joys of domestic retirement were *published* would be enough to suggest the conflicting feelings of their authors, but these feelings are evident in the poems themselves, as the passages we have quoted suggest. The figure onto whom many women poets (and even some men poets) projected these conflicts was the early 6th-century Greek poet Sappho of Lesbos, who played a role for female poets comparable to that played by Milton or Tasso for male: she was a great poet (honoured by the ancients as one of their best) but she suffered greatly. She was not seen, for the most part, as a 'lesbian' as we use the word today; what she was known for, besides a few surviving scraps of brilliant verse, was her suicide by leaping off the Leucadian cliff after she was abandoned by her lover Phaon, a man. Ovid had told the story in his *Heroides* 15, a letter from Sappho to Phaon. She is alone, her father dead, her brother gone, and Phaon far away in Sicily; she takes no pleasure in the fact that her fame as a poet is known in every land. She has rent her clothes, wept in grief, and wandered in a frenzy through the caves and woods where they once made love. She pleads with Phaon to return. If he does not, she vows to follow the advice of a Naiad, who told her she will find peace if she leaps from the high cliff of Leucas, in the Ionian Sea. In part mediated by Alexander Pope's version (1712), this heart-rending letter fired the imagination of numerous women poets.

Mary Robinson in 1796 wrote a sequence of 44 sonnets entitled *Sappho and Phaon* that meticulously charts her life, her passion for Phaon, his departure, her voyage to Sicily, her confrontation with the false Phaon, her resolution to die, and her final thoughts as she stands on the Leucadian rock. Madame de Staël wrote *Sapho*, a play in five acts (1811). In 1824 alone, Letitia Elizabeth Landon wrote 'Sappho's Song', Catherine Grace Godwin wrote *Sappho:*

A Dramatic Sketch, Mme Sophie Denne-Baron published a 'Sapho' in *Almanach des Muses* in Paris, and the Russian poet Elizaveta Kulman wrote a very long poem called 'Sappho'. Two years later, Amable Tastu published 'Chant de Sapho', a dirge for Sappho's friend Erinna. In 1831, Felicia Hemans produced 'The Last Song of Sappho'. Carolina Coronado composed 'Los cantos de Safo' and 'El salto de Leucades' in 1843. And so it went, along with paintings, cantatas, operas, and ballets. Men were taken with the theme almost as often, and it would be interesting, if there were more space, to explore the reason why this was so. In 1793, for example, Southey in England and Kleist in Germany wrote dramatic poems about Sappho, Byron treated her in *Childe Harold*, Canto 2 (1812), and Giacomo Leopardi poured his despair into 'Ultimo canto di Saffo' in 1822.

The purport of these works varies, but again and again they harp on the hollowness of poetic fame in comparison with love. Yet passionate and erotic love, like Sappho's, is also shown to be dangerous and irresponsible in comparison with tender domestic devotion. Admirable though she is, Sappho's case is a warning, and a warning more to female poets, of course, than to male. It is true that Byron once claimed that he would give up all his laurels if he could win the love of a beautiful young woman ('Stanzas Written on the Road between Florence and Pisa'), and he frequently gestured at the meaninglessness of fame when he had a lot of it, but the moral of Sappho's sacrifice was mainly directed at women, for whom love and duty to a man were expected to be the centre of their existence.

The Sappho theme received a powerful but complicated impetus in Madame de Staël's novel *Corinne, or Italy* (1807). Its title character is an astonishing young woman, beautiful, brilliant, independent, cosmopolitan, an accomplished actress, poet, and *improvisatrice* (one who improvises verse before audiences who propose subjects), whom we meet in the opening chapter as she is being crowned with laurel (as Tasso was to be) in Rome before an enthusiastic crowd.

She is a new Sappho: indeed her name evokes the ancient poet Corinna of Tanagra, said to be the teacher and rival of Pindar; she is a new sibyl, a prophetess of a restored Italy (then under domination by Napoleon); and, as the subtitle suggests, she is an embodiment of Italy herself, glorious but powerless. She meets Lord Oswald Nelvil, a brave and intelligent Englishman harbouring an obscure guilt and a commitment to a woman at home, and they fall in love. They do a great deal of sightseeing and have many discussions of Italian, French, and British literature and culture; they spend some hours on the rim of smouldering Vesuvius, where Oswald reveals his troubled history; there are revelations on her part a week later (she turns out to be the half-sister of Oswald's intended!); they both wrestle with the question of whether she could still follow her vocation if she were a wife and a mother. Then the inevitable happens: he must return to England. She follows in secret, there are misunderstandings, and a long train of suffering and renunciation lumbers to its tragic end. The plot is absurdly unlikely and melodramatic, and it carries too much allegorical freight; the moral, to the extent that it can be extracted, would be depressingly familiar to women of that time who sought independence and a chance to express their genius; but Corinne is irresistibly interesting and attractive. She seems to transcend the plot that humbles her and to retain her power over the reader long afterwards, or so she evidently did to many women throughout Europe and America. They must have rewritten the story in their heads to make it possible for love and literary fame to cohabit, as it seems to have, fitfully, in the life of Madame de Staël herself, but in their poems they seem to scold Corinne for even imagining she might find happiness as a poetess.

The novel had scarcely appeared when Adélaïde Dufrénoy wrotc 'Corine à Oswald', echoing not only the epistles in the novel but Ovid's 'Sappho to Phaon'. This Corine [*sic*] is ready to relinquish her 'useless lyre' and take her place at Oswald's side, readier than Staël's Corinne, but she suggests at the end that the loyalty of a docile helpmeet has less love in it than the passionate gift of a poet.

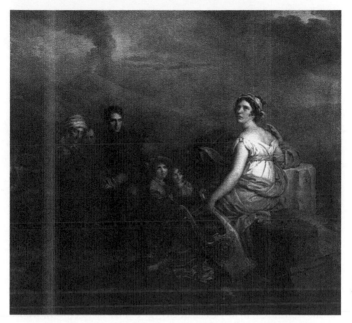

8. François Gérard, *Corinne at Cape Miseno* (1819). Corinne has just finished a recital of a poem, as her lover Lord Nelvil looks intently on, Vesuvius smoking behind him. Gérard used Staël herself as the model for her famous heroine

Less ambiguous was Mary Browne's 1828 poem 'The Poetess', which claims that 'glory's false star' soon fades and a woman's heart belongs at home where the light of fame never intrudes. Letitia Landon turned to the subject several times, in 'Corinna' (1821), 'The Improvisatrice' (1824), and 'Corinne at the Cape of Misena' (1832), while Felicia Hemans joined in with 'Corinne at the Capitol' (1830). Hemans's poem ends in a maddeningly typical way:

> Radiant daughter of the sun!
> Now thy living wreath is won.
> Crowned of Rome! Oh! art thou not

Happy in that glorious lot?
Happier, happier far than thou,
With the laurel on thy brow,
She that makes the humblest hearth
Lovely but to one on earth!

Responses like these to the more divided impact of the original
character seem like attempts to stifle the free and creative spirit of
women. With the often terrible fates of the male poets in view, not
to mention their often scandalous conduct, one can almost
sympathize with propriety's attempts to keep its daughters safely at
home. But to repress the poetic genius is to repress Romanticism,
and it becomes questionable whether many of the 'poetesses'
belong in a short book on the subject like this one except as a
contrast to Romanticism or a rebuke to it. Were there space
enough, it would be interesting to consider Anne Elliott's warning
against reading Byron in *Persuasion* (1818) or Mary Shelley's
cautionary tale against overweening male genius, *Frankenstein*
(1818). The struggle of women artists against the stifling social
norms continued, in any case, in George Sand's *Lélia* (1833), whose
heroine is a new Corinne with new ideas about love and
independence, and in Elizabeth Barrett Browning's *Aurora Leigh*
(1856), whose heroine is a descendant of those by both Staël
and Sand. In the Romantic era, the poet-prophet, in all his
grandeur and misery, was assumed to be male, but Corinne,
the poetess-sibyl, equally grand and miserable, was a harbinger
of an era to come.

Chapter 4
Religion, philosophy, and science

If poets were assuming the roles of prophet and priest, as I have
tried to show, what religious beliefs were they heralding or serving?
Can Romanticism be understood as a new religion? In Chapter 1,
I quoted T. E. Hulme's sneering description of Romanticsm as
'spilt religion'. It arises, he wrote, from the rationalist critique of
traditional, 'classical' Christian doctrine, a critique that suppresses
the natural outlet of our religious instincts, which must then come
out another way.

> You don't believe in a God, so you begin to believe that man is a god.
> You don't believe in Heaven, so you begin to believe in a heaven on
> earth. In other words, you get romanticism. The concepts that are
> right and proper in their own sphere are spread over, and so mess
> up, falsify, and blur the clear outlines of human experience. It is like
> pouring a pot of treacle over the dinner table.
>
> (*Speculations*, 1924)

If we can extract his assertion from his disdainful wit, with which
he implies that Romanticism is a case of bad manners, Hulme does
capture something central to it. It is not hard to find claims that
man is, or might become, divine. William Blake saw the
Incarnation of God in man not as uniquely confined to Jesus Christ
but as a continuing capacity in all our lives: 'God becomes as we

are, that we may be as he is' (1788). 'By our own spirits are we deified', Wordsworth wrote in 1802. Friedrich Schlegel claimed 'Every good human being is always progressively becoming God' (1800). What made Jesus unique, said Emerson in his 'Divinity School Address' (1838), was not that he alone became God, but that he alone 'saw that God incarnates himself in man'. This sort of claim struck many observers as blasphemous or at least grandiose; to some, it raised the spectre of religious 'enthusiasm' among early Protestants, who were blamed for the religious wars of the 16th and 17th centuries. A dubious observer of the American Transcendentalist movement, the counterpart of German and British Romanticism in which Emerson played a major part, called it 'ego-theism'. ('Transcendentalism' was a misleading label, as its adherents emphasized the immanence rather than the transcendence of God.) Hulme would have been heartily amused to learn that Victor Hugo, whom he particularly despised for his windy rhetoric and cosmic mistiness, was made one of the three saints of the Cao Dai sect in Vietnam, founded in 1926; it still has a million or more worshippers.

Or take the New Testament miracles, long held by most Christians to be proof that Jesus is the Messiah. David Hume and other Enlightenment philosophers redefined miracles as violations of the laws of nature and therefore dismissible as ignorant fables. Friedrich Schleiermacher, in his *Speeches on Religion* (1799), redefines them again, in psychological terms: 'Every event, even the most natural and usual, becomes a miracle, as soon as the religious view of it can be the dominant', a view available to anyone who is open to the infinite universe. And he adds: 'To me all is miracle.' Schleiermacher and other German Romantics prompted the 'miracle controversy' among Boston ministers a few decades later, which culminated in Emerson's speech of 1838. Jesus 'spoke of miracles', Emerson said, 'for he felt that man's life was a miracle, and all that man doth, and he knew that this daily miracle shines, as the character ascends'. Some Romantics made a similar move with the idea of the holy. Blake, for instance, denounced the

traditional view of holiness as Satanic, and reminded us that Jesus rent the curtain before the Holy of Holies in the Temple. 'For every thing that lives is Holy' (1793). Schleiermacher agreed: 'To a pious mind religion makes everything holy, even unholiness and commonness.' And Keats wrote to a friend in 1817, 'I am certain of nothing except the holiness of the Heart's affections and the truth of the imagination.'

Here are leakage and spillage enough: God, miracle, and holiness escape from their traditional 'classic' categories and spread across the human race, and even into nature. As if anticipating Hulme, Hugo summed up his religious views in his poem 'God' (written in 1856), in which he ridiculed attempts to apply dogmas to God and 'put darkness and eternity under lock and key'. But let us restate Hulme's account of Romantic religion in a different way. The traditional, more or less orthodox, Christian view places God at the apex of a triangle whose lower corners here below are the soul and nature (or the world). Except for his unique Incarnation as the Son in Jesus Christ, God is transcendent; he is not part of nature but its creator, nor is he part of our souls, which he also created, except insofar as the Holy Spirit may enter into them. (Indeed, the 'enthusiastic' Protestant sects that laid stress on the Holy Spirit within us are precursors of Romanticism.) The Christian's ultimate purpose is to unite with God, and to do so requires having as little to do with 'nature' as possible, 'nature' encompassing all material things, including the body. At best, nature may be honoured as God's creation, filled with signs to guide us to Him, but also planted with snares and delusions. But in the minds of many educated Europeans of the 18th century, the Enlightenment's attack on superstition, and the successes of Copernican astronomy and Newtonian physics, removed God from his throne as an object of worship, performer of miracles, or dictator of moral codes, and demoted Jesus to the rank of great preacher and moral example. The attenuated 'God' that remained, the God of Deism, was at most the creator of the universe and its regular laws. He has done nothing for us lately.

The Romantic generations by and large accepted the dethronement of the transcendent and active God, that is, the reduction of the triangle to a line between soul and nature. 'What I see first of all in romanticism', Northrop Frye wrote in 1963, 'is the effect of a profound change, not primarily in belief, but in the spatial projection of reality'. Instead of directing one's emotional fervour vertically to a transcendent God, the Romantic typically directed it horizontally – either outward towards the depths of nature or inward towards the depths of the soul. They parted company from the rationalist critics who preceded them in wishing to preserve the religious experiences of the believer, the feeling of mystery, of ecstasy, of yielding to the infinite, as well as the aesthetic delights of churches and their art and music. It is as if the soul and nature, the earthly corners of the Christian triangle, are the legatees of God: God is dead, but his divinity is bequeathed downward, along with the feelings it inspired. Schleiermacher, whose writings on religion were of the first importance for the Romantics, agreed in advance with the anti-Romantic Hulme that religion is inherent in human nature, but waved away 'systems of theology', which are not 'religion itself', not 'the religious life', but merely its 'dead letter'. 'The sum total of religion is to feel that, in its highest unity, all that moves us in feeling is one.' The germ of religion itself is 'a feeling of being one with nature, of being quite rooted in it'. It is a serene surrender to the universe on which we depend. It is, I think, more a change in belief than Frye would allow, for it is almost a replacement of belief by feeling. Feeling, in any case, became the main thing, not doctrine. 'Religion', Mme de Staël wrote in *Corinne*, is 'the purest feeling of the heart'.

The religion of nature

Long before the Romantics, of course, some people found evidence of God's existence, and his wisdom and power, in the realm of nature. 'The heavens declare the glory of God', Psalm 19 opens, 'and the firmament sheweth his handywork'. Several poets of

Sensibility or Romanticism, such as Klopstock, Friederike Brun, Christopher Smart, William Cowper, and Coleridge, wrote poems in this spirit. They saw God at work not only in the firmament but in small things as well. Not only by thunder, earthquakes, and volcanoes is their Maker revealed, according to Smart (1754), but He 'in works of a minuter mould / Is not less manifest, is not less mighty.' Victor Hugo writes in the grander register of this tradition in 'Extase' ('Ecstasy') (1829), where he hears the woods and hills murmur questions to the stars of the night and the waves of the sea; they in turn reply, 'It is the Lord, the Lord God!'

But this was not a distinctively Romantic view. In 'Lines Written a Few Miles above Tintern Abbey' (1798), Wordsworth describes a state of mind that is like a mystical trance:

> that serene and blessed mood,
> In which the affections gently lead us on,
> Until, the breath of this corporeal frame,
> And even the motion of our human blood
> Almost suspended, we are laid asleep
> In body, and become a living soul:
> While with an eye made quiet by the power
> Of harmony, and the deep power of joy,
> We see into the life of things.

It is not a vision of God, or of God's handiwork, but of 'the life of things', a vague enough phrase, but clearly about an immanent, 'horizontal' orientation, and with the implication that this world of things is alive. Later in the poem, he returns to this mood or visionary power:

> a sense sublime
> Of something far more deeply interfused,
> Whose dwelling is the light of setting suns,
> And the round ocean, and the living air,
> And the blue sky, and in the mind of man,
> A motion and a spirit, that impels

> All thinking things, all objects of all thought,
> And rolls through all things.

This 'something', this 'motion and a spirit', is as close to God as Wordsworth comes in this poem, and it is not very close. Yet he uses religious language, not only in these passages but especially near the end of the poem, where he declares,

> I, so long
> A worshipper of Nature, hither came,
> Unwearied in that service: rather say
> With warmer love, oh! with far deeper zeal
> Of holier love.

Later, when he had grown more conservative, Wordsworth was thrown on the defensive by these lines, which some readers complained of, but they remain a touchstone of the Romantic veneration of nature.

Some Romantics, who preserved in some fashion the Christian belief that Nature is God's work, added the less common but still very old belief that it is also God's word. In 'Frost at Midnight' (1798), Coleridge addresses his baby son:

> so shalt thou see and hear
> The lovely shapes and sounds intelligible
> Of that eternal language, which thy God
> Utters, who from eternity doth teach
> Himself in all, and all things in himself.

'Nature', Wackenroder wrote in 1796, 'is like a fragmentary oracular utterance from the mouth of the Divinity.' It was common, especially in German poetry, to claim that nature utters a message to those who are fit to hear it. Novalis imagined a 'secret word' that would banish all the pseudo-knowledge that prevails today ('When numbers and figures', 1802). In 'Departure' (1815), Eichendorff declares:

There is written in the forest
A silent solemn word
On doing right and loving
And what we must hold dear.
I have read them truly,
These plain and simple lines,
And they throughout my being
Grew wonderfully clear.

Friedrich Schlegel in 'The Thicket' (1802) posits not a word but a significant 'sound' audible in the roaring of seas and rustling of leaves. It concludes:

One soft sound through every sound
Of earth's bright-coloured dream
Sustains its sound for him alone
Who secretly gives heed.

It is not surprising that musicians liked this poem: Schubert set it in 1819, and Schumann used the final lines as the motto to his *Fantasie* in C for piano, opus 17 (1839). Some of the later French Romantics took this idea to a spooky extreme. 'Even to mere matter a word is attached', wrote Nerval in 'Golden Verses' (1845); 'In obscure things may dwell a hidden God; / And like a nascent eye covered by its lid, / A pure spirit grows beneath the husk of stone!' 'Nature is a temple', Baudelaire wrote, 'where living columns / Sometimes let confused words come out; / Man walks through these forests of symbols / Which observe him with a familiar gaze' ('Correspondences', 1857).

The German painter Caspar David Friedrich seemed to the Romantics to embody their ideas in his exquisitely detailed and haunting landscapes. Several of them show a Gothic ruin amid fir trees, or leafless oaks in winter (such as *Abbey in the Oak Forest*, 1809–10), evoking uncertain thoughts in the viewer: Has the Gothic building become 'natural' as time and nature work on it? Or, on the contrary, is nature a church or cloister, like Baudelaire's

temple, with religious instruction for us? And if so, has that teaching died in today's winter of reason and urban rootlessness? The paintings have so mesmerizing a beauty that they can 'tease us out of thought', as Keats said of his Grecian urn, and leave us in a kind of awed trance, with religious feelings spilling in all directions. Friedrich also painted several mountainous scenes with a cross or crucifix high on a rocky outcropping, of which the most famous is the *Cross in the Mountains* or *Tetschen Altarpiece* (1807–8). Heavily framed in gilt, with cherub heads above and the Masonic eye of God below, we see the crucifix from well below; fir trees stand on the slopes leading up to it; the Christ figure faces partly away from us towards the rays of the setting sun; the rays widen upward from far below (though this is not possible in reality) against a reddened sky. If this altarpiece is intended for a church, to which denomination would it belong? It is Christian in certain obvious respects, but does it also portray the beautiful sunset of the church of Christ, like the 'melancholy, long, withdrawing roar' of the sea of faith in Matthew Arnold's 'Dover Beach'?

Greek paganism

The poets' personification of nature or such natural things as stones is only a step away from pagan polytheism. 'They will come back, those gods you always mourn for', Nerval wrote in another sonnet, 'As time restores the order of the ancient days' ('Delphica', 1845). Wordsworth felt that 'the world', with its 'getting and spending', had left him so forlorn, so alienated from nature, that he would rather be a pagan, so he could see Proteus in the sea, and hear Triton blowing his horn ('The world is too much with us', 1807). Such a yearning for the Greek gods, goddesses, and nymphs was untypical of Wordsworth, who was more likely to find his imagination nourished by medieval ruins, but it was the frequent resort of the next generation of British poets, Byron, Shelley, and Keats. In his 'Ode to Psyche' (1820), for instance, Keats has a vision of Psyche asleep beside her Cupid, and then proclaims, 'I will be thy

priest, and build a fane [temple] / In some untrodden region of my mind' – 'mind' being an English translation of Greek *psyche*. No Christian allegory appealed to Keats as strongly as the pagan myths. The same is true of Shelley, who called himself an atheist but found religious truth in these same myths. His greatest work, *Prometheus Unbound* (1820), is a profound rethinking of the struggle of Prometheus the friend of humanity against Jupiter the tyrant god; Shelley's hero overthrows the tyranny through a withdrawal of hatred and a kind of Christlike self-sacrifice.

It was over Germany, however, that the cult of the Greeks held greatest sway. Even before his 'classical' maturity, Goethe makes Prometheus his spokesman for independence from tyrannical gods and from the orthodoxies of literary taste. 'I know of nothing under the sun, Gods, / More miserable than you!' Spurning them as projections of the foolish fancies of children and beggars, Prometheus turns to creating the human race 'in my image'. It was Goethe's friend Schiller who wrote the most influential pagan poem of the era, 'The Gods of Greece' ('Die Götter Griechenlands'), an elegy mourning their extinction at the hands of Christianity and of science. Once nymphs inhabited every tree and fountain, while gods walked among mortals, fell in love with them, raised some of them to Olympus, and fathered mortal or immortal children on them, but now the world is barren. 'Now where, as our wise men tell us, / Only a soulless fireball revolves, / Then aloft in his golden carriage / Rode Helios in quiet majesty.' 'Lovely world, where are you?' The blossoms of the Greek springtime of humanity were blown down 'by dreadful windstorms of the north. / *One* among them all to make the richer, / This whole world of gods has passed away.' The 'one' was the 'holy barbarian' (*heilige Barbar*), 'whom a woman bore'. Needless to say, indignant Lutheran pastors denounced this poem as soon as it appeared (1788). But that made it all the more attractive to the Romantic generation, such as Hölderlin, whose elegiac poem 'Bread and Wine' (1800–1) also asks where the gods have gone. 'Athens is withered, and Thebes.' There are no more games in Olympia. 'Why are they silent, too, the

theatres, ancient and hallowed?' Schiller ended the revised version of his poem (1800) by declaring that the gods have gone home to Mount Pindus, but 'live on immortally in song'. Hölderlin also imagined them now in another realm – 'Though the gods are living, / Over our heads they live, up in a different world' – but they will return, when their time is due. Meanwhile, we poets drink the gift of the 'wine-god', who seems to be both Dionysus and Jesus, and compose hymns in his honour (tr. Michael Hamburger).

In France, Alfred de Musset indulges in a similar nostalgia: 'O Greece! . . . / / I am a citizen of your ancient ages; / My soul with the bee strays beneath your porticos' (1831). But Giacomo Leopardi in Italy finds almost no consolation for the loss of the gods in his poem 'To Spring, or, Concerning the Ancient Fables' (1824). He mourns the loss of 'that fair former age' when gods danced on the mountain tops and the shepherd heard Pan's pipes along the river bank. Now we have no kinship with them, Olympus is empty, and the thunder, no longer sent by Zeus, wanders aimlessly and frightens innocent and guilty alike. At the end, Leopardi turns to nature with a forlorn plea to listen to our troubles 'if you still live', or if even one being somewhere in nature at least takes note of our sorrows, even if it will not pity us.

The sublime

Earlier we met Wordsworth's phrase 'a sense sublime / Of something far more deeply interfused' in his poem 'Tintern Abbey'. The idea of 'the sublime' gained currency in the 18th century as a category that applies both to writing – it was used to translate the ancient Greek word *hypsos* ('loftiness') in Longinus' treatise on literary style – and to such natural objects as mountains, seas, and waterfalls, as well as to such states of mind as Wordsworth's 'sense'. It was often contrasted with 'the beautiful', which was taken as a gentle, serene, often feminine quality, appropriate to rolling hills, fertile valleys, and well-tended estates; the sublime arouses terror at the vastness and power of wild, ungovernable nature. This

terror, however, is terror at a distance, where the viewer is safe enough to contemplate it rather than flee. In his *Critique of the Power of Judgment* (1790), Immanuel Kant named tall cliffs, towering thunder clouds, volcanoes, hurricanes, 'the boundless ocean set into a rage', lofty waterfalls, and the like as overwhelming compared to our puny powers.

> But the sight of them only becomes all the more attractive the more fearful it is, as long as we find ourselves in safety, and we gladly call these objects sublime [German *erhaben*] because they elevate the strength of our soul above its usual level... [and] give us the courage to measure ourselves against the apparent all-powerfulness of nature.

(tr. Guyer and Matthews)

Sublime nature calls forth the sublime in our soul. To return to our Christian triangle: after the removal of God, who was the ultimate sublime power, we rediscover his sublimity in nature, which is no longer necessarily seen as his creation, and in our own mind that responds to it. Sometimes, indeed, nature at its most sublime can seem like a mind itself, as it does in Wordsworth's great passage about the crossing of the Alps in *The Prelude* (1805), where

> The torrents shooting from the clear blue sky,
> The rocks that muttered close upon our ears –
> Black drizzling crags that spake by the wayside
> As if a voice were in them – the sick sight
> And giddy prospect of the raving stream,
> The unfettered clouds and region of the heavens,
> Tumult and peace, the darkness and the light,
> Were all like workings of one mind[.]

At a comparable moment atop Mount Snowdon near the end of the poem, the scene presents 'the perfect image of a mighty Mind'. With the same vision, Shelley cries to the steep valley of the Arve below Mont Blanc; 'Dizzy Ravine! And when I gaze on thee / I

seem as in a trance sublime and strange / To muse on my own separate phantasy, / My own, my human mind' ('Mont Blanc', 1817). More often, striking scenes of natural grandeur seem to speak eloquently to an attentive soul, as we saw in poems by Coleridge, Schlegel, Nerval, and others. The Russian poet Baratynsky stands before the vertiginous height of a great waterfall, 'And my heart seems to understand / Your wordless utterance' ('The Waterfall', 1821). To Leopardi, however, the sublime Mount Vesuvius seems only cruel, or worse than cruel, in its utter indifference to the human lives it destroys ('The Broom', 1836); he stands at the edge of Romanticism here, disillusioned though still prompted to speak to the great volcano.

As for sublimity in writing, it was found in Ossian, not only for his sublime settings on rocky, storm-tossed coasts but for his own (or Macpherson's) style, with its biblical cadences, vague but tragic plots, rhetorical questions, and the like. Thomas Gray in 1757 had described Milton as 'he, that rode sublime / Upon the seraph-wings of Ecstasy', and Edmund Burke, in his *Philosophical Enquiry into ... the Sublime and the Beautiful* (also 1757) found instances of the sublime in passages from *Paradise Lost*. Shakespeare, especially his tragedies, Dante, Homer, and other greats were praised for their sublimity. Sainte-Beuve praises Hugo's 'sublime flight' (1829); soaring flights, indeed, became a staple of the sublime.

It was at this time, too, beginning in the 1790s, that symphonic music began to seem sublime, no doubt mainly for its large forces with their overwhelming sound and capacity for abrupt transitions. But it was Beethoven above all who came to stand for sublimity, especially after E. T. A. Hoffmann's 1813 essay on his instrumental music, music 'which opens up to us the realm of the monstrous and the immeasurable. Burning flashes of light shoot through the deep night of this realm'; we feel 'the pain of that endless longing in which each joy that has climbed aloft in jubilant

song sinks back and is swallowed up' – that 'infinite longing that is the essence of romanticism' (tr. Oliver Strunk).

In the wake of the widespread discussions of the sublime among philosophers and poets, Romantic painters as well made ambitious efforts to depict sublime scenes in sublime ways. J. M. W. Turner mastered the evocation of terrifying storms on land or sea by blurry brushwork, sharp contrasts of light and dark, and the uncertain standpoint of the viewer. In his *Hannibal Crossing the Alps* (1812), the Carthaginians are dwarfed by the sweeping dark clouds of a snowstorm, while in a similar subject, *Snow Storm: Steamboat off a Harbour's Mouth* (1842), we see an almost surreal vortex of cloud and water centred on the steamboat, from a vantage hard to conceive (not the safety of the shore). Friedrich's manner of painting is almost the opposite of Turner's loose, sketch-like brushwork, but his meticulously finished landscapes can be just as terrifying and evocative. He often places a figure or two, facing

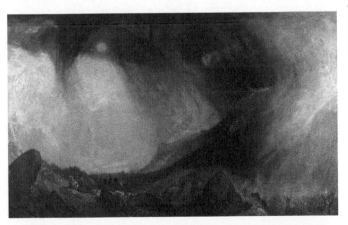

9. J. M. W. Turner, *Snowstorm: Hannibal and His Army Crossing the Alps* (1812). The sublime in painting. This major event in human history is reduced to almost nothing by the gigantic Alps and the towering stormcloud, made all the more menacing by the difficulty of reading the scene through Turner's rough brushwork

away from us and looking into what we see, as he does in *Chasseur in the Forest* (1814), where the small cavalryman, without his horse, stares into an impenetrable evergreen forest in winter, but he can portray sublime scenes as cruelly indifferent as Leopardi's Vesuvius. In his *Arctic Shipwreck* (1824), the slow crushing of the ship by colossal slabs of ice seems even more disturbing than the swirling seas in Turner's several shipwreck paintings.

The religion of art

If poets have become modern prophets and priests, it seemed natural to look at ancient prophets and priests as poets. The Bible came to be seen, and newly appreciated, as a work of literary art. To an othodox believer, merely to appreciate the Bible, to look at it as a

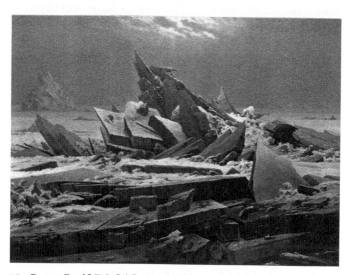

10. Caspar David Friedrich, *Arctic Shipwreck* (1824). The sublime in painting, but in a very different style from Turner's. The precision of Friedrich's fine brushwork reveals the enormous inhuman forces behind the almost architectural construction at the centre, which will easily crush the ship at the right

work of literary art, was to deny its authority, though some Romantics might reply that to place it among such works as the *Iliad* or *Hamlet* would be to grant it a great deal of authority indeed. In any case, the now commonplace idea of 'the Bible as literature', the title of a thousand university courses, gained its impetus in the periods of Sensibility and Romanticism. We saw that Macpherson may have been led by Robert Lowth's explorations of the structure of Old Testament verse to cast his Ossian songs in similar parallelisms; Lowth was widely read and discussed throughout Europe and America.

The German philosopher Georg Hamann thought the Bible is essentially poetic, and God is 'the poet at the beginning of days' (*Aesthetica in Nuce*, 1762). The Bible, said Blake, is 'Poetry & that poetry inspired'; 'The Old & New Testaments are the Great Code of Art'. Blake's longer poems are steeped in biblical allusions and imagery, but he was not afraid to rewrite the Bible, or to read it in its 'infernal sense' (punning on 'internal sense'), as he enlisted it into his own mythology. The Bible was less central to Wordsworth, but he responded to the power of 'Jewish Song', as he put it in *The Prelude* (1805). Blake spoke of 'the sublime of the Bible', and Coleridge agreed that 'Sublimity is Hebrew by birth', not Greek. Byron wrote that the atheist Shelley 'was a great admirer of Scripture as a composition'; he particularly admired Job, Ecclesiastes, and the Song of Songs, the most 'poetic' of the books except for the Psalms, which doubtless struck Shelley as too pious. Hugo, Vigny, and other French writers constantly resorted to the Bible, not only to rewrite its stories but to borrow its styles.

It was J. G. Herder, the German philosopher and historian, who most influentially transformed the way contemporaries read the Bible by emphasizing that it is a product of human beings living at a particular time and place. Its authors, being Hebrews, often composed in a luxuriant, metaphorical, 'oriental' mode, in verse, and it is simply false to their spirit to take them as scientists or historians. In his wake, several German writers, like their English

counterparts, looked in Scripture for something deeper, or higher, than literal truth. In 'the creative, poetic impulse' of the Bible, Schleiermacher wrote, we find an attempt to arouse a loftier state of mind in us, but if we offer it 'servile reverence' it will become a mausoleum. Though he made translations of biblical texts, Hölderlin argued that religious feelings cannot be expressed in literal statements or concepts, but only in myth. Herder supposed that new Bibles might appear, with new revelations adapted to our times. Friedrich Schlegel, writing of the medieval idea of the 'Everlasting Gospel', a third testament embodying the third Person of the Trinity, claimed it would appear not as a new Book, but as a series of books, which is what the original testaments were. Blake knew this old tradition well: he wrote a piece called 'The Everlasting Gospel' and promised the world a new Bible from his own hand.

If they took the Bible as literature, many Romantics also took the Church as art. Schelling, Novalis, Wackenroder, and Tieck all found the liturgy of the Catholic Church a source of religious inspiration quite apart from its doctrine. In his lengthy study of *The Genius of Christianity* (1802), Chateaubriand devoted far more space to the literature and art of Christianity than to its teachings. 'You cannot enter a Gothic church', he wrote, 'without experiencing a kind of shudder and a vague sentiment of divinity'. This *frissonement* is what appealed to Chateaubriand, and to the many who responded to him: an aesthetic enchantment, a shiver of the sublime, a hushed respect for the ancient mysteries, a nostalgia for the age of belief. The young Théophile Gautier nicely catches the gentle melancholy of the post-religious soul in his 'Sonnet I' (1830): 'In the shimmering windows of the dark churches / The flames of the western sun flame and die away', it begins, almost as if it were a caption of a Friedrich painting; 'Precious relics of an age that is no longer, / Their vaults trace a black shape against an azure sky.' The church bell seems to sound from far above, 'And the poet, sitting near the waves, on the shore, / Hears the fleeting tones as though they float in dreams, / And, gazing at the sky in sadness, he

recalls.' Just what he recalls is left to our imagination, but we may be meant to think of the Platonic doctrine of recollection, as if the bell ringing from on high reminds the poet of an irrecoverable former life.

Groups or circles of Romantics tended to think of themselves as disciples or dedicated brothers. It had been common for over a century for Parisian writers, artists, and intellectuals to be invited to attend a regular salon or two, often hosted by an aristocratic lady, but during the 19th century several salons were formed by the writers themselves, often around a journal, such as *La Muse Française*, which was edited by the Deschamps brothers in 1823 and 1824. The most famous coterie was organized by Victor Hugo and Charles-Augustin Sainte-Beuve a few years later; it met frequently at Hugo's house and became known as the *Cénacle*. That word comes from Latin *cenaculum*, which means 'dining room' or 'upper room at an inn', and is used in the Latin Bible to refer to the room where Jesus and his disciples met. Sainte-Beuve in his poem *Le Cénacle* (1829) makes the parallel excruciatingly explicit. Once

> Some holy disciples gathered in the evenings
> In the guest room, just a few, on their knees, and spoke
>> Of the great miracle,
> United, believing, strong with an angel's faith,
> For tongues of fire turned and hovered above them –
>> A strange oracle.

In our days, 'A genius has arisen here amidst the storm, / Young and strong', the very Victor Hugo in whose dining room we gather; 'at the sound of his trumpet, / At his voice of thunder that a chorus echoes, / . . . Jericho will fall!' Sainte-Beuve singles out a few other noble poets and painters, and then addresses the group as a whole: 'Brotherhood of the arts! Fortunate union! / Evenings whose memory, even after many years, / Will charm us in old age!' This *cénacle* spawned several others, as the Romantics repeated the fissiparous habits of the early Christian sects.

In 1810, four art students at the Vienna Academy moved to Rome, where they painted religious subjects and lived a monastic life. They called themselves 'The Nazarenes'. And the composer Robert Schumann, in serious jest, invented a little circle of devoted musicians (based on real ones such as Clara Wieck and Felix Mendelssohn) which he named 'The League of David', after the biblical king who was both a musician and the slayer of the Philistine Goliath. In his journal, *Neue Zeitschrift für Musik* (*New Journal for Music*), founded in 1834, the *Davidsbündler* would campaign for great music such as Bach's, Beethoven's, and Schubert's against the shallow and theatrical stuff popular with the 'Philistine' bourgeoisie. 'Philistine' in this derogatory sense – a stolid, boorish person interested only in worldly success – had been in use among German college students since the 17th century for 'townies'. Goethe's Werther uses it this way, as does Novalis, who writes, 'Philistines lead only a daily life'. It entered English through Thomas Carlyle's writings on German literature.

One of the strongest claims for the religion of art came from *Outpourings from the Heart of an Art-Loving Friar* by the German Romantics Wackenroder and Tieck (1797), a set of essays mainly about the great Renaissance painters Leonardo, Michelangelo, Raphael, and Dürer, and which claims that, for an artist, 'Art must become a sacred love or a loved religion', while for anyone, 'The appreciation of sublime art works is akin to prayer.' One section is a rapturous poem about Raphael, through whom art's divinity shone most beautifully. A generation later in France, Alfred de Vigny looked with gentle irony on the 'faithless churches' of his day, 'Whose soul used to be prayer in days now gone'; today painters come to gaze in ecstasy at the works of art inside, 'priests of art', who at least pray for the church though they do not believe in its ancient teachings ('The Organ' (1834), tr. Blackmores).

In *Outpourings*, an imagined disciple of the Protestant Dürer writes to a friend, 'I have now gone over to the Catholic faith.... It was the irresistible power of art which won me over' (tr. Mornin).

Friedrich Schlegel and his wife Caroline converted to Catholicism in 1808, though it is not clear whether it was art that won them over. It has been common for two centuries now, in literature and in life, for, say, an English or American Protestant to visit Rome and fall in love with the architecture, painting, sculpture, music, ritual, and incense of the churches and abandon his or her ascetic, icon-averse faith. It is easy to mock it, but such a conversion rests on well-considered Romantic premises about what religion really is.

Idealism

Although the Romantics by and large acknowledged the arguments of the Enlightenment philosophers against theology, they remained 'religious' in the broad sense we have been describing. Their intuitive feeling of kinship with the natural world, however intermittent, their conviction that they could know this world truly, at least in certain exalted states of mind, kept them at a distance from these philosophers, particularly on the terrain of epistemology or the theory of knowledge. The Romantics disagreed pointedly with the British empiricists John Locke and David Hume and their followers, who posited a model of the mind as the largely passive recipient and storehouse of sensations from its environment.

In his *Essay on Human Understanding* (1690), Locke likened the human mind, famously, to a 'blank slate', or *tabula rasa*, before it is impressed with sensations from outside. We come into the world with no innate ideas (Locke is arguing against 'rationalists' who thought we were born knowing certain truths, religious and otherwise) but acquire all ideas through our five senses. Not quite truly blank slates, we are innately endowed only with certain basic functions, such as the ability to compare and contrast ideas and perform inductions from data. Through their similarity, continuity, or contiguity, ideas link themselves with other ideas and form ever more complex sets or trains. Those ideas that we

might attribute to an inborn imagination, such as a unicorn, are merely the combinations of simpler ideas, while abstract concepts, such as virtue or solidity, are generalizations or inductions from many individual cases. The mind is not inactive, but it comes no better equipped, we might say today, than a computer with only a disk-operating system, before a program such as Windows is loaded. The mind, then, is a creature of its circumstances, and all it knows is based on what arrives through its five inlets.

William Blake despised this doctrine, and he confronted it with logical arguments in his earliest engravings. He dismissed the five senses as mere chinks in a cavern, and imagined a time when we had 'enlarged & numerous senses' before we fell for a false theory (*Marriage of Heaven and Hell*, 1793). His most startling and brilliant case against it is eloquently voiced, and embodied, by Oothoon, the resilient heroine of *Visions of the Daughters of Albion* (1793). The plot, and the name of the heroine, is a revision of Ossian's *Oithona*, where the betrothed Oithona, raped by an abductor, chooses to die even though her lover, who has killed her assailant, loves her still. Oothoon, intercepted and raped on her way to her lover, recovers from her violent assault with no spiritual damage, but her lover, Theotormon, cannot get over it and sees her as indelibly stained, indeed branded, by the rapist. 'Arise my Theotormon I am pure', she cries in the first of several long speeches, 'Because the night is gone that clos'd me in its deadly black.' She then seems abruptly to change the subject to epistemology: 'They told me that the night & day were all that I could see; / They told me that I had five senses to enclose me up.' But she has not really changed the subject: it is as if the disciples of John Locke raped her, 'they' who told her these things. But these are falsehoods. 'With what sense is it that the chicken shuns the ravenous hawk?' she asks. 'With what sense does the tame pigeon measure out the expanse? / With what sense does the bee form cells?' They all have the same senses, but their worlds and pursuits and joys are all unique. They are born with an inner fountain of knowledge, just as she has a pure spring within her that has

washed away her stain. Her love for Theotormon is so strong that she is still a virgin in every way that matters, and she denounces the sexual jealousy and possessiveness that beclouds her lover. But he is unworthy of her, and the poem ends in a tragic stalemate, all because of the ideology that believes we are no more than the sum of our experiences.

In 'Tintern Abbey', Wordsworth announces, 'Once again / Do I behold these steep and lofty cliffs, / Which on a wild secluded scene impress / Thoughts of more deep seclusion.' This sentence is an interesting epistemological tangle that reveals the effort Wordsworth makes to understand his mind's relationship to nature. In the Lockean scheme, the cliffs would impress the beholding mind, which would associate these impressions with ideas in its memory and produce appropriate thoughts. But here it is the thoughts that are impressed on the secluded scene, making it seem more secluded; the mind does the impressing, not the cliffs. Yet it is the cliffs after all that enlist the thoughts and impress them on the scene, as if Wordsworth is a mere vehicle of the cliffs' activity, or as if the cliffs themselves think these thoughts. Later in the poem, Wordsworth writes that he loves 'all the mighty world / Of eye, and ear, both what they half create, / And what perceive', and thereby suggests that the cliffs and his mind work together, as joint creators of what he beholds. Half-creation, though it sounds like a compromise, is still a long step away from Locke.

Wordsworth's friend Coleridge, struggling with what he feared was the loss of his creative power in 'Dejection: An Ode' (1802), bravely declared:

> we receive but what we give,
> And in our life alone does Nature live:
> Ours is her wedding-garment, ours her shroud!
>
> . . . from the soul itself must issue forth
> A light, a glory, a fair luminous cloud

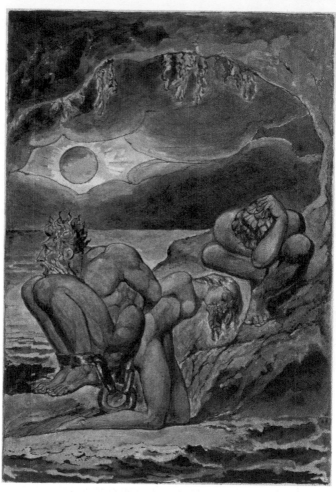

11. William Blake, frontispiece to *Visions of the Daughters of Albion* (1793). Oothoon is bound back-to-back to her rapist (Bromion) while her lover (Theotormon) buries his head in despair and jealousy. That the mouth of a cave where they sit, with the clouds and sun, resembles a skull suggests that it is Theotormon, holding his own skull, who is permanently chaining Oothoon to her violator

Enveloping the Earth –
And from the soul itself must there be sent
A sweet and potent voice, of its own birth,
Of all sweet sounds the life and element!

This much stronger claim (one which Wordsworth too would echo in other poems), that the soul must originate the perceptions we receive, Coleridge owed in large part to his intense study of contemporary German philosophy, mainly Kant and Schelling.

Immanuel Kant was dissatisfied both with the rationalist philosophy he had been trained in, the tradition of Descartes and Leibniz, which taught that objective knowledge of the world was possible through innate ideas and reason, and with the empiricist tradition of Locke and Hume, which taught that knowledge, which must come from the senses, must therefore be subjective and very uncertainly in touch with the external world. It was David Hume in particular, with his doubts that we even know such seemingly 'given' data as the self and causality (for causality is a subjective notion we illegitimately project onto the 'constant conjunction' of perceived events), who roused Kant from his 'dogmatic slumber'. The result, first fully laid out in his *Critique of Pure Reason* (1781), argued that for any experience at all to be possible, the mind must contribute certain forms of intuition, such as space and time, and certain fundamental concepts or 'categories', such as substance and causality; these, at least, are born in the soul. Sensation is passive, but conception, or the grasping of sensations with concepts, is active, while experience is the synthesis of the two. We cannot know 'things in themselves', but what we do know, 'appearances', are not subjective only, for the perceptible world is the product of 'transcendental' concepts, that is, the categories presupposed by any experience, and which compose the structure of all minds capable of any experience at all. There is ultimately a harmony between the external world and the mind.

Kant called his proof of the role of the human mind in structuring the world a 'Copernican Revolution', and Friedrich Schlegel called him 'the Copernicus of philosophy', rather oddly, for Copernicus moved the human viewpoint away from the centre of things. Kant certainly started a major new movement, at first called 'transcendental idealism', which attracted poets as much as philosophers: Schiller, the Schlegels, Novalis, and Hölderlin, for instance, all wrote philosophical essays trying to come to grips with the new idealism. Like all revolutions, it kept revolutionizing itself, as one assertion or another was questioned and rethought. There was discontent over Kant's notion of 'things in themselves', or *noumena*, for instance, which lurked rather mysteriously behind the *phenomena* that we can experience; the Romantics disagreed with this bifurcation of the world, which seemed to reintroduce the Humean subjectivism Kant claimed to reject. Kant's follower Fichte had taken the activity of the subject as the key to metaphysics: we know only what we make, we create the world by our actions, and there is no other world behind it. Whether this emphasis is truly Kantian or not, most Romantics rejected this subjectivism and made the contrary claim that nature is the primary fact and force, and that human consciousness is nature's product, not its creator. Emerson's extreme formula – 'The Universe is the externization of the soul' ('The Poet') – would be reversed by most Romantics: the soul is the internization of the universe. Nature is an organism, forming a great complex and dynamic unity, and this unity guarantees the objectivity of our perceptions, the harmony of subject and object. In his *Critique of the Power of Judgment* (1790), Kant had argued that the concept of nature as an organism or intelligence might have heuristic or 'regulative' value, but we could not say that nature was really constituted in that way. The philosopher Schelling, in concert with his friends in the Romantic circles, insisted that nature really was an organism, and it achieved self-consciousness through us. He has been called an 'absolute idealist', but for him, the 'Absolute' was not a subject or ego, as it was for Fichte, and as it seemed to be for Kant, but a neutral midpoint, a kind of substance that is neither

subject nor object but the basis of both. We have, as a result, a power of intuition that resembles aesthetic perception, an intuitive grasp of nature in its unity and infinitude. Or we have it when our imaginative power is awake. To see nature as lifeless, finite, a mere set of things and events, as the British empiricists did, is to see it with dead eyes. Indeed, the true fall of humanity is the loss of our imaginative power, the vital vision, that married us to nature. Our sinfulness is a separation from it. To see nature as dead, we must be dead ourselves. 'Ours is her wedding-garment, ours her shroud.'

Pantheism

Schelling was inspired to break with Fichte and the subjectivist side of Kant by his reading of the 17th-century philosopher Spinoza. Baruch (later Benedict) Spinoza was a Sephardic Jew of Portuguese ancestry who was born and lived in relatively tolerant Amsterdam. His opinions about religion were so heretical that his synagogue expelled him with a fierce anathema, and he was also considered dangerous by the Protestant establishment. In his central work, *The Ethics*, published at his death, Spinoza argues with forbidding logical rigour, in Latin, as if he were making geometrical proofs, that there is only one substance, which he calls 'God', which has two known 'attributes', thought and extension. Twice he uses the phrase *Deus sive Natura*, 'God or Nature', which encapsulates his monism. God and nature are ultimately identical. Though the German Romantic Novalis was to call him 'God-intoxicated', presumably because 'God' appears on almost every page, Spinoza was widely considered an atheist, because the God he describes is entirely incompatible with the Christian or Jewish God, who is a supernatural intelligence who transcends the nature He created.

A century after his death, Spinoza had attracted a few heterodox thinkers and natural philosophers, but was taboo in respectable intellectual circles. Then the 'Pantheism Controversy' broke out in

Germany in 1785, when F. H. Jacobi claimed that the famous Enlightenment philosopher Gotthold Ephraim Lessing had admitted he was a Spinozist when Jacobi showed him Goethe's poem 'Prometheus', which we quoted from earlier in this chapter. Jacobi, a faithful Christian, had meant to warn off readers tempted by reason-based philosophy by showing that it would lead to Spinozism, that is, atheism, but his book had the opposite effect, and soon young intellectuals were poring over Spinoza. In his *Conversations on Poetry*, Friedrich Schlegel wrote, 'I hardly understand how one can be a poet unless one honours, loves, and appropriates Spinoza.' Schleiermacher praised the 'holy, rejected Spinoza', who was full of the Holy Spirit. Schelling resisted Spinoza at first, then embraced his monism, though Schelling's notion of a living organic universe is not exactly Spinoza's idea, which reflected the mechanistic theories of his day. Coleridge struggled with Spinoza for years, saying in 1817, 'For a very long time indeed I could not reconcile personality [i.e., the idea of God as a "person", with intellect and will] with infinity; and my head was with Spinoza, though my whole heart remained with Paul and John.' Heinrich Heine in the 1820s described Spinoza as 'my comrade in unbelief'.

Spinoza had said that 'the intellectual love of God' is the highest and noblest state of mind, one free of personal passion or any self-regard, a serene contemplation of the laws of the universe. He did not believe that this 'God or Nature' should be worshipped; it certainly cannot be prayed to. His truest heir, perhaps, was Albert Einstein, who said, 'I believe in Spinoza's God, who reveals himself in the orderly harmony of what exists, not in a God who concerns himself with the fates and actions of human beings.' The term 'pantheism', a word Spinoza never used, got attached to his philosophy, as it seemed to express the Romantics' religious feelings for nature, or even a vague sort of polytheistic paganism. Though Wordsworth called himself a worshipper of nature, his description of the serene contemplative mood in which, 'with an eye made quiet by the power / Of harmony, and the deep

power of joy, / We see into the life of things' is very much in
Spinoza's spirit.

Science

It is one of the accomplishments of the Enlightenment that most
thinkers today take for granted that religion, philosophy, and
science are distinct domains with their own projects and
procedures. Many philosophers and scientists, indeed, would
dismiss religion altogether, and some scientists find even
philosophy more or less superfluous, but many scientists and
philosophers, and even some theologians, take the more charitable
view that they each have their own proper turf and should not
poach on the others. This was not the view characteristic of
Romanticism. Constantly striving for unity between subject and
object, feeling and knowledge, fact and value, truth and beauty,
Romantics typically saw these three domains as one. It is not that
they reverted to the pre-Enlightenment system, in which theology
was the queen of the sciences, though some of them hankered for
the medieval or early Renaissance world. Most of them embraced
the Enlightenment, but sought a new synthesis whereby faith,
science, and reason ('reason in her most exalted mood', as
Wordsworth wrote) would be different faces of the same universe,
and that all of them would express the cultivation, or *Bildung*, of
the human spirit. 'Romanticism was the revolutionary
reawakening of the Enlightenment', Marshall Brown has recently
written, and most Romantics, no less than their Enlightenment
forebears, took a keen interest in the sciences.

This claim, I admit, does not square with the usual view that
Romanticism was hostile to science, or 'natural philosophy', as it
was then called, and tried to flee its cold, hard world of facts. In
'The Gods of Greece', we saw, Schiller complains that our wise men
tell us that the sun is a 'soulless fireball' revolving where Helios
once rode majestically in his chariot; he feels that nature, 'bereft of
the gods', has become 'the law of gravity's most humble servant'.

Blake wages intellectual war against Isaac Newton as a figure for the most monocular sort of outlook, 'Single vision & Newton's sleep' (a thrust at Newton's *Optics*), whereas it takes fourfold vision to 'see a world in a grain of sand'. Keats, in 'Lamia' (1820), also deplores Newton's theory of light:

> There was an awful [sublime] rainbow once in heaven:
> We know her woof, her texture; she is given
> In the dull catalogue of common things.
> Philosophy will clip an Angel's wings,
> Conquer all mysteries by rule and line,
> Empty the haunted air, and gnomed mine –
> Unweave a rainbow[.]

Echoing both Schiller and Keats, Edgar Allen Poe's sonnet 'To Science' (1845) calls it a 'Vulture, whose wings are dull realities': 'Hast thou not dragged Diana from her car [chariot]? / And driven the Hamadryad [tree nymph] from the wood / To seek a shelter in some happier star?'

It is nonetheless the case that Romantics typically followed scientific developments with great attention, and particularly those that seemed to challenge the mathematical Newtonian picture. As we might expect, Schelling, with his insistence that nature was an organism, worked out an elaborate *Naturphilosophie* which he called the 'Spinozism of physics'. Unlike Spinoza, however, he opposed the 'mechanical' model, according to which the material world was ordered like a machine; nature is not only organic, it is living activity or productivity itself, with an inherent intelligence not imported by a creator God but arising from within through a polarity of forces. He was struck, in particular, by the startling new developments in chemistry, electricity, and magnetism, all of which seemed to reveal forces within living bodies, not to mention action at a distance, which (like Newton's gravity) seemed inexplicable under the mechanical paradigm. Spinoza had denied that the two attributes or aspects of substance could interact, for they are parallel and categorically distinct, but Schelling thought

they could do so, for life and consciousness must have emerged from matter somehow. The best scientists of the day thought gravity, light, heat, electricity, and magnetism were all fluids and had an as yet unknown connection with one another (we are not far from Einstein's search for a unified field); Volta and Galvani were suggesting that electricity and magnetism were 'vital' or 'animating' forces, and mesmerism (or hypnotism) was explained as a working of 'animal magnetism' in the human body, and soul. A union of body and soul, too, underlay the theory of phrenology, put forth by Franz Joseph Gall in the late 1790s, which saw the brain as the expression of the mind, and the skull as an expression of both; the size, shape, and even bumps of the head were true indicators of the mind within.

Coleridge was a close friend of the great chemist Humphry Davy and attended many of his celebrated scientific lectures and inhaled laughing gas with him; Davy, for his part, was as interested in poetry as in chemistry and electricity. Percy Shelley, sometimes taken as the most etherial or otherworldly of poets, carried a microscope and other instruments with him on his extensive travels, and as a boy would terrify his little sisters and then his schoolmates with loud and smelly experiments. His *Prometheus Unbound*, true to the fire-bringing spirit of the god it honours, is filled with references not only to electricity and magnetism, but to infra-red radiation (discovered by Herschel), the hydrogen cycle in decaying plants, volcanism, planetary orbits, and the evolution or improvement of life on earth. Among others, Shelley had been reading Erasmus Darwin, who had penned large poems in rhymed couplets on *The Botanic Garden* (1789–91) and other scientific subjects, in some of which he speculated about biological evolution, which his grandson Charles was to vindicate. Like Goethe before him, Shelley made use of the work of Luke Howard, who is responsible for the modern nomenclature of clouds. Mary Shelley's novel *Frankenstein* (1818), informed by her reading of Humphry Davy and others, accepts the possibility of infusing the vital principle into dead body parts, but of course

it has become a byword for two centuries for the dangers of scientific hubris.

Most of the Romantics were guilty of no such hubris, but they saw in the latest discoveries of science a confirmation of their intuition that deep within the natural world and deep within their souls was a living bond, and that in certain heightened states of mind they could understand the language nature spoke. The great scientists, including Newton, were just as much visionary geniuses and heroes of independent thought as the great poets and artists. Science has travelled far since the days of phrenology and animal magnetism, but perhaps it is circling back, with its ideas about ecology and the living earth, to a new Romanticism.

Chapter 5
The social vision of Romanticism

If you placed them on a line from 'left' to 'right', according to the political stands they took, you would find Romantics scattered along the full length of it, though gathered more thickly on the left. Some of them would move a fair distance along it as they aged: Wordsworth became more conservative, Hugo more liberal. Some might have to be placed above the line or below it, for their complicated viewpoints are hard to classify, and the left–right line is, to be sure, one-dimensional. One fact, at least, would stand out, a surprising fact to anyone who thinks the Romantics were preoccupied with the self, or nature, or love: most of them were passionately committed to political causes. Madame de Staël, loyal to the original liberal spirit of the French Revolution, was banned by Napoleon from Paris; she set up a kind of a salon *cum* government-in-exile at her estate at Coppet, near Geneva. Byron sat (briefly) in the House of Lords, where he gave a radical speech sympathetic to the frame-breakers, or 'Luddites', in Nottingham (1812), and he died a hero in Greece, where he had gone to aid the revolutionaries. Pushkin could have been implicated in the 'Decembrist' uprising in St Petersburg (1825), in which several of his friends took part; the Tsar himself became Pushkin's personal censor. Lamartine became president of the provisional government of the Second French Republic (1848); Hugo was elected a senator for Paris in 1876. In less lofty circles, Wordsworth made two extended visits to France, possibly three, during the early

years of the Revolution, and was 'pretty hot in it', as he later said; he and Coleridge befriended John Thelwall, one of the leaders of the working-class London Corresponding Society who had recently been acquitted of treason by a sympathetic jury, and during a visit by Thelwall the three were watched by the Home Office in 1797. The Polish-Lithuanian poet Mickiewicz was arrested for political activities in 1823 and banished to central Russia; from his later exile in Paris, he went to Istanbul in 1855 to organize an army to fight the Russians in the Crimea, but died of cholera. Ugo Foscolo, the Greek-Venetian poet, spent most of his life in exile for political activities; he served in Napoleon's army; he was an eloquent advocate of Italian reunification and independence. To these examples (and there are many more), we might add that not only Foscolo but quite a few other Romantics were soldiers: several of the Russians, Chateaubriand, Vigny, Petöfi, and, in intent at least, Byron and Mickiewicz.

The French Revolution

The successful struggle of the American colonies for independence was often in the minds of the first Romantic generation. Indeed, Coleridge and Southey planned to emigrate to the banks of the Susquehanna to start a utopian farm, and similar ideas were afloat throughout Europe. But the founding of the United States was an event in the past. What gripped the imaginations of those who were young in 1789 was, of course, the revolution in France, inspired, in part, by events in America, but vastly more cataclysmic.

The French Revolution permanently transformed the opinions, political formations, party alignments, and dreams and nightmares of Europe and beyond; it even gave us the terms 'left' and 'right'. What happened in France, the most populous and powerful state in Western Europe, with the greatest cultural prestige, and whose language was adopted by ruling elites as far east as Russia and understood by most educated Europeans, had repercussions almost everywhere. It passed through many phases

at a rapid pace: the largely nonviolent sit-in by the Third Estate, until it became the National Assembly, leading to a constitutional monarchy (1789); the storming of the Bastille in Paris; the Declaration of the Rights of Man and Citizen; the flight and capture of the king, leading to threats by Prussia and Austria (1791); their invasion of France the following year; the September massacres, the Convention, and the founding of the Republic; the execution of Louis XVI (1793); war with Britain; the Terror, led by Robespierre with his guillotine; civil war in the countryside; reaction against the Terror and fall of Robespierre (1794); the rise of Napoleon from general (1796) to First Consul (1799) to Emperor (1804), along with an astonishing series of victories, followed by catastrophic defeats in Russia (1812) and, at the end, Waterloo (1815); the restoration of the Bourbons and the Old Regime; the Congress of Vienna. There had been nothing like this series of political earthquakes: participants and distant observers alike were roused to passionate and extravagant words and deeds. The Revolution seemed sublime at times, both beautiful and terrifying, like a force of nature too great to be comprehended.

For the most part, those Romantic poets and artists who were youths or young adults in 1789 welcomed the Revolution in its first phases. Wordsworth famously wrote, 'bliss was it in that dawn to be alive, / But to be young was very heaven!' The early German Romantics declared themselves republicans and held their ground despite the French invasion of the Rhineland (1794). But as the Revolution lurched this way and that, many Romantics gave up on it: they may have stayed with it through the killing of the king and even the Terror, which was fairly brief, but the invasion of Switzerland (a republic!) in 1798, or the crowning of an emperor by a pope (1804), was enough for most of them.

In 'France: An Ode' (1798), first titled 'The Recantation', Coleridge describes his early devotion to the Revolution, and how he bravely 'sang defeat' of those who joined the war against France, which included his own beloved country, but now he asks Freedom for

forgiveness as he hears its 'loud lament, / From bleak Helvetia's [Switzerland's] icy cavern sent.' Wordsworth went through several crises, clinging to hopes for France until 1802, when a brief truce came to an end; he labels the crowning of Napoleon by the pope as a contemptible reprise of the overthrown monarchy, 'the dog / Returning to his vomit' (1805, *Prelude*, 10.934–5). The first generation of German Romantics began to turn against the Revolution by the end of the 1790s, but drew the lesson that the common people, manifestly unfit for a republic after centuries of superstition and oppression, needed to be educated by wise leaders – not by philosophers or even philosopher-kings but by poets and artists, who can imagine and make attractive the ideal of a good society. Wordsworth and Coleridge, by contrast, seemed to renounce politics in favour of nature and a rich interior life. Coleridge's recantation ends with the claim that liberty is never found 'in forms of human power' but only in the forests and seas, while Wordsworth concludes *The Prelude* with the promise that he and Coleridge, 'Prophets of Nature', will teach others how the mind of man is 'above this frame of things' and remains unchanged "'mid all revolutions in the hopes / And fears of men' (13.442 ff). Nonetheless, both of them, though increasingly conservative, rejoined social and political controversies for decades.

A second group of German Romantics, living in Heidelberg, became more reactionary and nationalistic, as did Friedrich Schlegel of the Jena-Berlin group. Johann Joseph von Görres, for instance, an essayist and editor of outspoken journals, was at first caught up in the excitement of the Revolution, but turned against Napoleon, and pamphleteered against him to considerable effect. He preached German nationalism, and deplored the Congress of Vienna, which restored the *status quo ante*; in the end, he thought help could come only from a rejuvenated Catholic Church.

The second generation of British Romantics, who came of age at about 1810, were less demoralized by the Revolution's failures or betrayals, and remained committed to liberal and even

revolutionary causes. In Canto 3 of *Childe Harold's Pilgrimage* (1816), Byron repeats the commonplace that the French had thrown off tyranny only to 'renew / Dungeons and thrones', but then avows that there is no going back. 'Mankind have felt their strength, and made it felt.' Despite the restoration of the *ancien régime*, 'none need despair: / It came, it cometh, and will come, – the power / To punish or forgive – in *one* we shall be slower', that is, in punishing those we defeat (780–96). P. B. Shelley devoted two major works to rethinking the Revolution, *The Revolt of Islam* (1817), a long Spenserian romance-epic only half-disguised in its thin Islamic setting, and *Prometheus Unbound* (1820), a 'lyrical drama' set in a kind of eternal antiquity. With Byron, he saw that without forgiveness and reconciliation, no social transformation is possible, so his new revolutionaries are nonviolent, taking no revenge when victorious and gaining their victory not by seizing power but by dissolving the power that prevailed. He made his case more simply and memorably in *The Mask of Anarchy* (1819), his indignant response to the 'Peterloo' Massacre outside Manchester, where cavalrymen dispersed a large but peaceable crowd of workers with a good deal of bloodshed. That, too, he rethought, imagining the workers this time refusing to flee, but standing 'with folded arms' before the horsemen with their swords. A century later, Mohandas Gandhi would read this poem aloud to his followers in India.

What about the Romantics in France itself? It has been argued recently that the Revolution displaced French Romanticism, or even stood in for it, until 1820, when Lamartine's poems set it off. It is difficult to assess such a claim. Certainly, the Revolution consumed enormous energies that might have gone into the arts. It consumed many lives, too, such as André Chénier's, a 'pre-Romantic' poet guillotined during the Terror (two days before it ended) in 1794; the publication of his poems in 1819 was one of the inspirations of the nascent Romantic movement. Yet Chateaubriand and Staël, though in exile for various stretches, wrote throughout the period. Chateaubriand had been

sympathetic to the Revolution at first, but its violence put him off, and he eventually joined an émigré army in Germany. After the 1800 amnesty, he held government posts under Napoleon, but broke with him a few years later. He joined the Bourbon regime in 1815, and soon became more royalist than the king. Madame de Staël remained liberal, at odds with Napoleon but no fan of the Bourbons. The second generation of Romantics, such as the group around Victor Hugo, was royalist at first, but most of them took more liberal views as time passed. France itself hardly settled down after 1815, as there were changes of regime in 1830, 1848, 1851, and 1870. Indeed, there were uprisings throughout Europe, especially in 1848; only Britain at one end and Russia at the other were fairly stable. If nothing else, the hopes raised and dashed, and raised and dashed repeatedly until at least mid-century, kept all observers on edge. Every traditional assumption about government and social relationships was now on the table.

The Industrial Revolution and the bonds of community

The second great revolution of the age was the Industrial Revolution, which began in Britain around 1775 with the invention of the steam engine and its efficient use in coke-smelting, along with technical innovations in spinning and weaving machines, which led to the great 'mills' in the new northern English cities and Glasgow. By about 1800, in the view of many historians, Britain had 'taken off' in every area of industrial production, and consumption, with the financial means, agricultural surplus, labour power, technical skill, transportation (canals at first), and overseas markets to make it irreversible. Britain led the way throughout the 19th century, though Belgium, France, Germany, and North America were not far behind. Of course, it was not abrupt like the French Revolution, its effects were gradual, so there are not more than a few allusions to it in the writings of the early Romantics. With his now famous phrase 'these dark Satanic mills' (1804), Blake was probably not referring to factories but to

intellectual mills that pulverize the soul – philosophies such as John Locke's. What we find most prominent in the first two generations of Romantics is a disdain for capitalist practices and commercialism in general, for the doctrine of utilitarianism which seemed to underlie them, and for urbanization. The horrors of the new factories emerge only by about the 1840s, and it was not until 1854 that the first thoroughgoing Romantic literary indictment of industrialism and its ideologies appeared – Charles Dickens's novel *Hard Times*.

In the sonnet we discussed in the last chapter, Wordsworth fears that 'the world', with its 'getting and spending', is ruining our kinship with nature. His dislike of commerce-ridden London, with a million people by 1800, is heir to a long 'country' tradition ('country' as opposed to London), which we find in James Thomson's 'Summer' (1727), which notes that the virtue that burns in a philosophical and 'enthusiastic' breast is what 'the sons of interest deem romance' (1388–91), and in William Cowper's *The Task* (1785), which claims, 'Improvement too, the idol of the age, / Is fed with many a victim' (3.764–5). 'Interest' and 'improvement' were two of the watchwords of the new era, and raised proper suspicions among Romantics and others, for whom 'romance' was not a disparaging term.

Even more characteristic were 'utility' and 'use'. Applying the standard of utility, the capacity to promote pleasure, Jeremy Bentham, the father of utilitarianism, notoriously found poetry no better than pushpin, the video game of the time. Institutes sprang up to promote 'useful knowledge'. 'Improvement' entailed making useful things, which made life's tasks faster, easier, more efficiently done, but to what end were all these improved means? Pleasure? That seemed so reductive and vague as to fall beneath contempt. Doesn't life itself have a use, some purpose beyond getting and spending and playing pushpin? Leopardi acidly dismisses 'this stupid age, which sets utility as the highest requirement, and fails to see that life becomes as a consequence more and more useless'

(*Il pensiero dominante*, 62–4). In his novel *Lucinde* (1799), Friedrich Schlegel writes, 'industry and utility [*der Fleiß und der Nutzen*] are the angels of death who, with fiery swords, prevent man's return to Paradise' (from the chapter on 'Idleness'). The uselessness of some things became a Romantic virtue – Staël's Corinne cries, 'Oh, how I love what is useless' (10.5) – and chief of these was beauty. 'Nature likes external beauty, and man likes it', Leigh Hunt writes in his postscript to 'Captain Sword and Captain Pen' (1835); 'It softens the heart, enriches the imagination, and helps to show us that there are other goods in the world besides bare utility.' In 'The Last Poet' (1835), Baratynsky deplores an age marching 'in its iron progression', devoted to self-interest and 'industrial pursuits', and able only to laugh when a great poet appears. Baudelaire laments in 'I love the thought' (1857) that the poet today, yearning to recreate the innocent sensual beauty of the Greeks, is thwarted by the implacable god, Utility. Sometimes, however, the Romantics tried a different tack, and retooled 'use' for a larger view. Wordsworth defends the old Cumberland beggar (in his poem by that name) from those who would lock him in a poorhouse for his own good. 'But deem not this man useless', he insists, for the beggar serves the community by binding it together in charity and kindness. Shelley is more direct in his *Defence of Poetry*: 'The production and assurance of pleasure in this highest sense is true utility. Those who produce and preserve this pleasure are poets or poetical philosophers.'

Self-interest, utility, and materialism drove some Romantic souls into private refuges or bohemian subcultures, where they could ever more despairingly scorn the ever more powerful bourgeoisie, but, as we saw, many of them were ready to emerge onto the public stage, even onto barricades and battlefields, when opportunities called and indignation and solidarity awoke. They were also prompted to give a good deal of thought to community or society. Older communal bonds seemed to be dissolving as multitudes crowded into London and Paris. Self-interest would hardly hold us together, nor would the 'cash-nexus', Thomas Carlyle's resonant

phrase. What would? The Romantics looked everywhere – to the guilds of the Middle Ages, to the cities of ancient Greece, to the tribes of 'noble savages' in America or Tahiti, to the clans of Scotland, even to the mysterious Gypsies – for models uncorrupted by capitalism and cash. Some, as we noted, turned to the Catholic Church, or the Church of England, for its traditional roots, its sense of community and 'communion' in the spirit, and its beauty. Novalis sets his novel *Heinrich von Ofterdingen* in an ideal medieval Germany where poetry-loving merchants circulate goods so everyone may flourish, and miners seek gold because it is 'an earnest symbol of man's life' (Chapter 5). Blake goes back to the New Testament and proclaimed brotherly love, or 'Brotherhood', as the deepest social bond, calling on us to 'annihilate our Selfhood', that illusory husk of fear, as we join into one community. Love, in fact, in the eyes of many Romantic social thinkers, is the fundamental social bond and our highest individual virtue. Friedrich Schlegel calls love 'the completion of community' (*Philosophical Fragments*, 101), while Novalis finds 'selfless love' the basis of the state: 'What is political union but a marriage?' ('Faith and Love'). Shelley's hero Prometheus brings about the defeat of the tyrant Jupiter by withdrawing the curse he hurled at him thousands of years ago; when his beloved Asia, who stands for love itself, rejoins him, Jupiter falls from his throne, since it was the failure of love in the first place that put him there.

Nationalism and internationalism

Love in this social sense sounds universal in many Romantic visions, as love of the human race, or 'philanthropy' (then a synonym for it), but it in practice was usually invoked as the basis for the 'nation'. The French Revolution had unified France and incited a deep patriotic fervour among millions of its citizens, as its mobilization of enormous armies of ill-trained but enthusiastic soldiers attested. Its patriotism, its throwing off of absolute monarchy, its liberation of peasants, slaves, and Jews, these inspired the literate classes in every country of Europe. Yet within a

few years, with the French occupations of Germany, Italy, Poland, and Russia, the pro-French nationalist impulses in these countries and elsewhere turned anti-French, as the universal ideal of the rights of man seemed contaminated by the presumption that France should control Europe. In Germany, where scores of tiny statelets were tenuously united under the antiquated laws of the Holy Roman Empire, and the idea of a German nation barely existed, Romantic writers were among the most prominent advocates of some sort of cultural, if not political, unity. It was the outsider Germaine de Staël, however, who gave one of the first literary impulses to German national pride with her book *On Germany*, written in 1810 but not allowed to appear until 1813, in which she not only defined and promoted Romanticism for readers everywhere, but also praised the somewhat impractical but intellectual, artistic, and peaceable German spirit and urged a German union. Well before this, Herder had advocated a revival of German culture, urging his readers to 'spit out the water of the Seine' and speak German, and to learn the history and customs of their people. He was not urging a new political entity but a cultural one, and indeed thought every people ought to find their own ethnic roots and preserve their vanishing folklore.

At this point, we should note the rise of the serious and widespread interest in history as a key characteristic of the era, one deeply implicated in the Romantic worldview, and much in debt to Herder. Eric Hobsbawm has written, 'an epidemic of history-writing overwhelmed Europe in the first half of the 19th century. Rarely have more men sat down to make sense of their world by writing many-volumed accounts of its past'. Many poets turned to history-writing: Southey to long histories of Portugal, Brazil, and the Peninsular War; Lamartine to a history of the Girondins; Pushkin to a history of the Pugachev rebellion. Everything – nations, culture, language, law, religion, economic systems, even the earth – was taken up from an historical point of view. This was the time, for example, when historical linguistics was properly launched, with a push from Herder and a key insight from Sir

William Jones, who saw that the ancient Indian language Sanskrit was closely akin to Greek and Latin. A great deal of the early work was done by Germans, notably the Grimm brothers, who not only collected their famous folk tales but compiled the first great German dictionary on historical principles. Jacob Grimm discovered the 'law', or regular sound shift, which ties the classical languages to the Germanic family: *pater* in Greek and Latin, for example, matches *Vater* in German and *father* in English, while Latin *frater* and Greek *phratria* correspond to *Bruder* and *brother*. Geology, too, was now seen increasingly as an historical subject: James Hutton of Edinburgh's *Theory of the Earth* (1795) argued that strata, rocks, and mountains required long ages to come about. And this was the era of the historical novel, almost single-handedly invented by Walter Scott, who began as a Romantic poet. His *Waverley* novels, named for the first (1814) of a long series, published anonymously, became the best-loved novels of Europe, and made millions of readers experts in Scottish history. Every one of them was turned into an opera, including a few that are still mainstays of the repertory, such as Donizetti's *Lucia di Lammermoor* (1835), from Scott's *The Bride of Lammermoor* (1819), and Bellini's *I Puritani di Scozia* (also 1835), from *Old Mortality* (1816). Scott's *Ivanhoe* (1819) was hailed as 'the real epic of the age' by Victor Hugo, whose own great novels *Notre-Dame de Paris* (1831) and *Les Misérables* (1862) are manifestly the products of a good deal of archival research.

The research and writing of history had much to do with the rise of nationalism, though enthusiasts need only a few historical nuggets to concoct inspirational national sagas, resulting in what Benedict Anderson has called 'imagined communities', to rally people around. For Novalis, the imagined community was quite imaginary, a Catholic Middle Ages without violence, tyranny, superstition, serfdom, or plague – only the bonds of brotherhood and the religion of beauty. But serious attention was given to real medieval works. August Wilhelm Schlegel in 1812 insisted that the *Nibelungenlied*, the forgotten Old-High-German epic, bore

comparison with the *Iliad* and should be taught in the schools. Ludwig Tieck published a collection of *Minnelieder* in 1803, and Achim von Arnim and Clemens Brentano, of the next generation of Romantics, brought out the first volume of their much-loved collection of folk songs in 1805, *The Boy's Magic Horn*. With such collections, the Germans were emulating the work of Macpherson, though taking fewer liberties in 'translating' their sources, as well as Percy's 'reliques'; soon Walter Scott was collecting 'border' ballads, and ardent cultural patriots in almost every country of Europe were gathering and processing their 'national' treasures. Gothic architecture, often in ruins, gained new appreciation, from painters such as Friedrich as well as poets and antiquarians.

Friedrich Schlegel, the main instigator of the early German Romantic movement, was at first a radical democrat. In 1796, he published an essay that defended democracy from Kant's objections (Kant was a republican, but not a democrat), advocating a broad franchise that included women, and defending the right of revolution. If he was ahead of his time in this, it was not long before he took the lead in a very different direction, a German 'nationalism' based on common ancestry and traditional ways, which preserved ancient freedoms but could hardly be considered democratic in a modern (or ancient Greek) sense. In an 1800 poem 'To the Germans', he called on his fellow Germans to drink the springs of true Germanness, while 'To the Rhine' in 1802 launched the cult of that river as the father of the nation. Before long, he was insisting on 'blood' or common descent as more important even than language and culture as the basis of a nation, and thought nations were like families, even one super-individual, into which the personal self should dissolve.

Madame de Staël was as interested in Italy as she was in Germany. Italy was as divided as Germany, and portions of it had long been under the control of foreign powers. The plot of her novel *Corinne, or Italy* (1807), comes to a halt several times as her poet-heroine discourses on the political passivity of her country. Since at least

Dante, of course, Italy's poets had appealed for national reunification, but in the Romantic era, with the French defeat of the Austrians in northern Italy, the theme was renewed with fervour. Ugo Foscolo's long poem *Dei Sepolcri* (*On Tombs*) (1807) is among other things a reply to Gray's 'Elegy in a Country Churchyard', in that it looks upon tombs not so much to moralize about the emptiness of worldly glory but to celebrate their civic function. The tombs of great men inspire great deeds in successive generations. Hence the importance of the Church of Santa Croce in Florence, where Machiavelli, Michelangelo, and Galileo are buried (now joined by Foscolo himself), as a national pantheon for a disunited country. In 'To Italy' (1818), the young Leopardi likens Italy to a weeping disheartened woman, and wonders why she cannot arouse the devoted patriotism that united the Greeks against the Persians in ancient times.

As for the Greeks, Dionysios Solomos, among other poets, celebrated Greek heroism in the struggles for independence from the Ottomans; part of his 'Hymn to Liberty' (1823) was adopted as the Greek national anthem in 1865. The greatest Polish-language Romantic poet, Adam Mickiewicz (1798–1855), was of Lithuanian origin, and is claimed by Lithuania as well as by Poland. He was intensely devoted to the Polish-Lithuanian confederation, and wrote lovingly about its ancient ways before the Russians and then the French trampled on them. The Hungarian poet Sándor Petöfi (born in 1823), wrote ballads, celebrated the free life of nature, honoured Ossian – and then, in March 1848, led the rebellion in Budapest that demanded liberal reforms and more local autonomy within the Austro-Hungarian Empire. His 'National Song' remains a popular patriotic anthem today. He joined an army to fight the Habsburgs and presumably was killed in battle in 1849, though reports circulated that he slipped away into Russia.

Nationalism rose in almost every country, or not-yet-country, of Europe, and Romantic artists and thinkers were usually contributing their vision of the folk, of ancient bonds of

community, and the slow organic growth of the 'nation' and its unique culture. After World War II, some intellectual historians laid the blame for Nazism at the feet of the Romantics, and not only Nazism but despotism and nationalism of many stripes. Such a case can certainly be made, but for every feature of Nazi ideology that can be traced to the Romantics, there is one that cannot. There was nothing about racial superiority in the early Romantics' celebration of the German spirit, and Novalis, for one, thought 'Germanness' was a state of mind, and that 'our old nationality was really Roman'. For most of them, the goal was a cultural renascence, not a nation-state based on common blood, and not a war of conquest or reconquest of former 'German' lands (though versions of both these ideas may be found in Schlegel). Finally, Herder and others thought that every 'nation' or people had a right to its place in the cultural sun, and many Romantics were intensely interested in the sheer diversity of human folkways and arts.

It is important to remember, too, how internationalist Romanticism was, at least in its first phases. We have already mentioned the travels that so many exiled Romantics had to undertake; many others journeyed willingly as tourists. Most of them could read several languages, with French the common tongue. They considered translations to be a vital part of their literary labours. Between 1797 and 1810, A. W. Schlegel translated seventeen of Shakespeare's plays (still considered the standard in German); five plays from the Spanish of Calderón; an anthology of poems from Spanish, Portuguese, and Italian; and the *Bhagavadgita* and other Sanskrit works into Latin. Dorothea Schlegel, Friedrich's wife, translated a set of medieval romances and Staël's *Corinne*, though both appeared under her husband's name. Chateaubriand translated Milton's *Paradise Lost*. Walter Scott made a version of Goethe's play *Götz von Berlichingen* as well as two ballads by Bürger, including 'Lenore'. Coleridge translated Schiller's *Wallenstein* and (it has recently been shown) Goethe's *Faust*. Felicia Hemans made translations of poems from Greek, German, Spanish, Italian, and Portuguese. And no one could be

more cosmopolitan than Madame de Staël herself, for all her efforts to instil national pride in Germans and Italians. 'Exile made me lose the ties that bound me to Paris', she said in 1814, 'and I became European'. She and the much-travelled Byron were emblems of the cosmopolitanism of Romanticism.

War

From April 1792, when France declared war on Austria and invaded the Austrian Netherlands, to June 1815, when Napoleon was defeated at Waterloo, Europe was almost continually at war. Historians distinguish different wars within the larger one because of the shifting alliances, treaties, and truces, but as one great war it deserves the title of 'World War I' for both its scope and severity: it was fought on land and sea from the Celebes to New Orleans, and the casualties were as large in proportion to the population as those of the war a century later, though they were spread out over twenty-three years instead of four. About one million men died in battle during 1812 alone. It has been called the first modern ideological war, in contrast to the typical wars before it, for it was not just about the territorial ambitions of kings, settled by small professional armies during the summer; it roused patriotic feelings in many countries, mobilized hundreds of thousands of soldiers at once, and was sometimes fought by irregulars and civilians. The Peninsular War (in Spain and Portugal) was particularly ugly; it gave English the word 'guerrilla'.

The great hero, or villain, of the war was, of course, Napoleon Bonaparte, whose generalship was so brilliant, and whose forces were so large and enthusiastic, that he seemed almost a god. By one count, he won 46 battles and lost 9, most of those 9 coming towards the end, with the destruction in Russia of the largest army hitherto fielded (610,000 men and 182,000 horses). He was fascinating to the Romantics: even those who despised him for betraying the Revolution and wading through blood across Europe and the Near East often acknowledged his genius, his

overwhelming charisma, his sense of destiny. The German philosopher Hegel is said to have called him 'the world-soul on a horse'. Hölderlin in 1797 found him too great to be contained in a poem, for his spirit, like new wine, would burst any vessel. Foscolo praised him the same year in a long ode 'To Bonaparte the Liberator', and though he soon felt betrayed by Napoleon's handing over Venice to the hated Austrians, he nonetheless joined Napoleon's army. On the news of his death in 1821, Alessandro Manzoni asked, 'True glory? Let the future / Its hard pronouncement give: /We bow to his Creator, / Who did more deeply leave / on one man's life and death / the imprint of His breath' ('The Fifth of May', tr. Tusiani). Pushkin, too, acknowledged Napoleon's destiny and glory, but at the end defined him as the unwitting vehicle of Russia's rise to greatness ('Napoleon', 1821). While Wordsworth, Southey, and Scott celebrated his defeat at Waterloo, the feelings of the younger British Romantics were more torn. Byron admired him, and drove a carriage modelled on Napoleon's own; after Waterloo, he wrote 'Napoleon's Farewell' and a reply from his troops, though in the end he was repelled by the bloodbath he poured over Europe. So was Shelley, who in 'Feelings of a Republican on the Fall of Bonaparte' (1816) cries, 'I hated thee, fallen tyrant!' He had prayed for his fall, Shelley says, but now he sees a greater evil assuming its former reign: 'old Custom, legal Crime, / And bloody Faith the foulest birth of Time.' Napoleon was preferable to that, at least.

As for the war itself, literature and all the arts had much to say about it that we can only glance at here. Much of the initial response, especially in Britain, was pacifist. Charlotte Smith, Coleridge, Wordsworth, and Southey, among many others, all wrote poetry that tried to bring home to an insensitive nation, safe behind its seas and navy, the calamities of warfare. The before-and-after descriptions of a battlefield; the returning soldier, crippled and traumatized; the widow, searching through the battlefield or waiting at home in despair; the ruined cottage and untilled field: these clichés of anti-war literature were sometimes

very movingly embodied, as we find in Wordsworth's 'The Discharged Soldier' (1798), later incorporated into *The Prelude*, and 'The Ruined Cottage' (1798), included in *The Recluse* (1814). As the war went on, disenchantment with the Revolution spread, and censorship tightened, poetry celebrating the war displaced poetry deploring it. Walter Scott's romantic accounts of Scottish battles were very popular, not only in Britain but in many languages on the Continent. Most readers today, having absorbed the great anti-war literature of World War I, find the martial poetry of 1800 to 1815 hard to take, with its glorification of manliness and its air-brushing of war's reality, but we should not forget how eagerly it was devoured.

The condition of women

Mary Wollstonecraft (1759–97), the brave and adventurous author of *Vindications of the Rights of Woman* (1792), is sometimes considered a Romantic, partly on the strength of her travel writings, though I think it is more accurate to describe her as a daughter of the Enlightenment with some traits of Sensibility. Despite her personal courage, her famous book is in many ways a very cautious vindication, advocating equality in education, for instance, but not the right to vote or hold office; woman's role is still that of wife and mother, and 'love' is a danger to the virtuous and rational 'friendship' that should prevail in marriage. She would have been shocked at Blake's free spirit Oothoon, though some scholars have thought Wollstonecraft inspired Blake to create her. Still, along with the redoubtable Germaine de Staël, with her brilliant Corinne, Wollstonecraft's example helped light the way for other women, a few here, a few there, as they broke with the codes and expectations of societies that scarcely entertained any doubt that men were superior to women and destined by nature to rule.

It is difficult to say if Romanticism was a help or a hindrance, all in all, to the improvement of women's lot. It could be argued that the Sensibility movement, with its ideal of 'feminine' responsiveness

and sympathetic tears, held more promise for women's social status than the Romantic movement, which had partly remasculinized the literary culture under the pressure of the war. As we saw in Chapter 3, the accepted role of the 'poetess' was distinct from that of the poet in its themes and ambition. But several women writers of the period protested in their work against the conventions that caged them in. Most remarkable, perhaps, is a poem by Annette von Droste-Hülshoff called 'Am Turme' ('On the Tower') (1844). It begins:

> I stand on the tower's high balcony,
> The shrieking starling streaks by.
> And like a Maenad I let the storm
> Rumple and tear at my hair.
> Oh my wild comrade and crazy boy,
> I long to embrace you and match
> My strength against yours, two steps from the edge,
> And wrestle with you to the death.

> (tr. Ruth Angress)

This intense love for the storm reminds one of Shelley's 'Ode to the West Wind' (1820), in which the suffering poet offers to submit himself to the 'wild' wind's power, but here the speaker shifts quickly from passively receiving the wind to the desire, at least, to match her strength with it. She then imagines herself amidst the waves at the beach below, which she describes as hunting dogs at play, and then on the prow of a naval ship in the distance, steering it across the waves like a seagull. She then sums up: if she were a hunter, or a soldier, or any sort of man, she would have 'the counsel of heaven', but instead she must sit like a good little girl and only in secret undo her hair for the wind. The candour, the erotic longing for the wind-god, implicitly Dionysus, and the sarcasm at the end, make this a daring and powerful poem.

A blunter sarcasm animates Carolina Coronado's poem 'Libertad' ('Liberty') (1852), which describes the latest political revolution in

Spain, this time a liberal one. All the men are happy, and 'I am happy for men', she writes, but what does 'liberty' mean to us women? We'll gain the right to speak from our patio and the right to sew. We'll gain the freedom to weep, as we have been doing for a long time. 'Therefore, I / don't cheer nor regret: / if they lose, God take pity, / if they win, I wish them the best' (tr. Eileen Myles).

Some male Romantics stood well in advance of their times in their attitudes towards women. Friedrich Schlegel's novel *Lucinde* (1799), thin in plot but thick with reflections on love, describes Lucinde and Julius as equal to each other and their (unmarried) love as both physical and spiritual; needless to say, it caused a scandal. Shelley was also an advocate of free love, and no less scandalous. He eloped with the daughter of Mary Wollstonecraft while he was still married to someone else, and the two tried for a time to live by his ideals, though it was often a misery for her. Byron, on the other hand, caused a scandal by his apparent affair with his half-sister, not for any advocacy of women's equality or freedom. Though he wrote some beautiful love poetry, we also find almost caddish male condescension to 'bluestockings' and other independent-minded women. On the other hand, he certainly granted that women have, and have the right to have, sexual desires. The record varies from man to man and woman to woman. Though Romantic values and beliefs might in principle be as attractive to women as to men – devoting a life to art, communing with the sublime in mountains, plunging into political activism – in practice, it was much harder for them, especially if they had children and lacked wealth, in a Europe only just beginning, here and there, to loosen its patriarchal order.

The exotic

It is more than a half-truth, if still simplistic, to say that the Romantics yearned for other places, other times, other cultures, almost anything other than the increasingly tedious, regimented, soulless, worldly life of modernizing Europe. When they could,

they travelled – Chateaubriand to the American wilderness, for example, and Byron to Albania – and when they could not, they travelled 'in realms of gold', as Keats did in his books. Quite a few European countries were seen as 'romantic' by natives of other countries. In Britain, for example, we find in Byron, Campbell, and others the phrase 'romantic Spain' as if it were a Homeric epithet and noun. Madame de Staël and A. W. Schlegel thought Spanish literature was the most romantic. Between 1800 and 1830, about a hundred plays were produced in France on Spanish themes, while Vigny, Nodier, Musset, and others wrote Spanish stories and novels. Italy seemed romantic, too, again in part because of Staël with her heroine Corinne. For centuries, the ruins of Rome had served as an occasion for meditations on the vanity of worldly things or the vicissitudes of empire, but they gained new prominence among the melancholic Romantics: Chateaubriand, Lamartine, A. W. Schlegel, and Wilhelm von Humboldt all wrote about them, usually as seen by moonlight, and Byron gave a good part to *Childe Harold's Pilgrimage* Canto 4 to them (1818). Scotland was also romantic, especially after the 'discovery' of Ossian, and then later during the *Waverley* novel craze. Greece was romantic, too, during the rebellion against the Ottomans, and especially after Byron died there. Musset's flirtatious Muse, who visits him in 'A Night in May' (1835), calls on him to fly off with her: 'Let's go, we are alone, the universe is ours. / Here is green Scotland and dark Italy, / And Greece, my mother...'

A favourite destination, in body or mind, was the 'Orient'. Somewhat elusively defined, it usually referred to the Near East or Middle East, that is, the Islamic world, though that would include North Africa, and even Spain, which had been under Moorish dominion for centuries before 1492. In the preface to his collection of poems called *Orientales* (1829), written during one of the crests of the 'oriental' vogue, Victor Hugo reports that he had been bathed in it almost without realizing it.

The oriental colours came as if to imprint themselves on all his thoughts, all his dreams; and his dreams and his thoughts have proved to be, and almost without his having wished it, by turns Hebraic, Turkish, Greek, Persian, Arabic, even Spanish, for Spain is still the Orient: Spain is half African [i.e., North African], and Africa is half Asiatic.

But the Orient could also include India, as the Sanskrit studies and translations of the Schlegels attest. (For some reason, the Far East seems not to have drawn the same interest; the *japonisme* fad came later.) Among Russian writers, of course, the 'Orient' was 'the South'.

As it appeared to Europeans at this time, the Orient was both attractive and repellent: attractive for its colourfulness, its former grandeur, its air of mystery and seclusion (the harem, for instance), its eroticism (the harem again, and dancing girls), the rare goods available in the bazaars (spices, silks, turquoise, hashish), the 'primitive' clan or tribal loyalties (much like those of Scotland), the caravans of camels, the desert scenery, and the climate; and repellent for its despotic governments, its fanatical religion, its cruelty, its mistreatment of women, its effeminate languor, and the sense that it is a sleeping tiger, which once nearly conquered Europe and might do so again. The categories of these features could almost be reversed, for what repelled could also allure, and vice versa. This ambivalence might be summed up in the image of the snake charmer, for the snake too, both beautiful and deadly, tries to 'fascinate' its prey even as the flute-player seems to charm the predator.

There had never been a period in which European culture was not engaged with the Orient – indeed, the emergence of 'Europe' as a cultural unity had much to do with its differentiation from the enemy at its gates – but from about 1800, the number and extent of oriental settings and themes in its literature begins to rise. Poetic tales led the way, such as Walter Savage Landor's *Gebir* (1798), which rather elliptically tells of the King of Iberia, Gebir, his conquest of Egypt, and his love for Charoba, Egypt's queen; and

12. Anne-Louis Girodet de Roussy-Triosson, *Chateaubriand Meditating on the Ruins of Rome* (1808). Chateaubriand lived in Rome briefly while serving as Napoleon's ambassador to the Vatican, an appointment that came to him on the strength of his book *The Genius of Christianity*. He soon broke with Napoleon, whom he likened to the Roman emperor Nero

Southey's *Thalaba the Destroyer* (1801), set in Arabia, and *The Curse of Kehama* (1810), set in India. It was Byron's immensely popular 'oriental tales', however, that gave the strongest push to this fascination with the East: *The Giaour* (1813), *The Corsair* (1814), *The Bride of Abydos* (1814), and *The Siege of Corinth* (1816). The first of these, named for its Christian hero in a Muslim land, seems a compilation of fragments in different voices (Byron kept 'finding' more fragments for later editions), and the resulting uncertainties made it all the more mysterious and interesting. It is a tale of illicit love, an escape from a harem, the killing of the beloved, and the giaour's revenge, liberally sprinkled with Arabic words, local place names, myths, and learned footnotes. Byron's friend Thomas Moore joined the trend with his very long and lavishly footnoted *Lalla Rookh* (1817), which also has a fragmentary air. So has Pushkin's *The Fountain of Bakhchisarai* (1821–3), inspired by Byron, a mysterious and tragic tale of love in a harem. Fragmentariness lent itself well to orientalist literature, as it not only concealed the ignorance of its authors but conveyed the sense that the orient really is opaque: you could strip off its seven veils and still have a mystery. Short lyric poems, such as Byron's *Hebrew Melodies* (1816) or Hugo's *Orientales*, often served the oriental mystique better. In the latter collection, Hugo offers an evocative little scene called 'Moonlight' inspired by the grim fate of Laila, the beloved of Byron's giaour. The sultana from her window hears a dull thud, and wonders if it is a boat from a Greek island, or a plunging cormorant, or even a djinn doing destructive magic, but no, it is one of several heavy sacks, out of which come sobs, as they are thrown into the sea. Less tragic, but still wistful, is 'The Captive Girl', presumably Spanish, who admits she rather likes the seashore, the warm rain, the streaming banners, the elephants with pavilions on top, the music, the dancing; most of all she likes to dream while watching the moon on the sea, 'opening its silver fan', in a little touch of homesickness. (Hector Berlioz made a series of musical settings for this *mélodie*, beginning in 1832.) During his wanderings in the Crimea, Adam Mickiewicz wrote a set of 'Crimean Sonnets' (1826), including a lovely

description of 'Bakhchisaray by Night', set after the evening prayers at the mosque, when the 'king of night is hastening home to lie by his beloved' and 'the harem of the sky' begins to shine.

13. Title page to 'La Captive': words by Victor Hugo, music by Hector Berlioz, design by Frédéric Sorrieu (1850). The girl, languishing in luxurious captivity, with the beautiful bay of Smyrna below her, gazes wistfully off into the distance, thinking of Spain

If the immurement and occasional drowning of women fascinated writers, so did suttee, the Indian practice of sacrificing the wife at the funeral of her husband. Two poems about it, both by women, are Günderode's 'The Widows of Malabar' (1804) and Letitia Landon's 'The Indian Bride' (1824). In her sonnet, Günderode imagines a group of women, dressed as if for their wedding, walking without fear or sorrow to the pyre of their husbands. 'Death becomes love's sweetest festal day', she concludes; 'They reach the peak of life when life is done.' Landon's much longer and more excitable poem draws the same conclusion: 'Ay, is not this love?— / That one pure, wild feeling all others above: / Vowed to the living, and kept to the tomb!' That 'love' seemed to be the motive behind suttee is an index of how far Eastern customs could be mythologized by the West.

Composers were not far behind in offering 'oriental' music; indeed, 'Turkish' marches had been a popular staple of 18th-century concerts. Rossini and Weber wrote operas set in the East. The French composer Félicien David travelled to Turkey and Egypt, and then wrote a series of 22 piano pieces called *Mélodies orientales* (1836), a very popular choral symphony called *Le Désert* (1844), and an opera, *Lalla-Roukh* (1862), based on the poem by Moore. Berlioz not only set several of Hugo's *Orientales*, but his oratorio *L'Enfance du Christ* (1850–5), which takes place in Judea and Egypt, has quite a few touches of Eastern modes and orchestration, such as the spinning dance of the soothsayers, inspired by reports of the whirling dervishes. Berlioz adds a graceful moment of conciliation between East and West, not found in the Bible, where Joseph in Egypt is hospitably welcomed by an Ismailite (or proto-Muslim) who is a fellow carpenter.

Among painters, Delacroix stands out as the great specialist in exotic subjects drawn from Romantic literature: Goethe, Chateaubriand, Dumas, Scott, and Byron. He painted *The Combat of the Giaour and Hassan* (1826) and several other scenes from *The Giaour*, four versions of *The Bride of Abydos*, the spectacular

Death of Sardanapalus (1827–8) (from Byron's play), and many other Byronic subjects. But he also made a trip to Spain, Morocco, and Algeria in 1832 that was crucial for his art. He never made the pilgrimage to Rome that had been almost obligatory for artists, but found the real 'antique' in North Africa. 'Rome is no longer in Rome', he wrote. 'Imagine, my friend, what it is to see Catos, Brutuses, lying in the sun, walking in the streets' of Algiers and Tangiers. About a hundred paintings and drawings grew out of this expedition, including such major works as *Women of Algiers in Their Apartment* (1834), *Jewish Wedding in Morocco* (c. 1839), and *The Sultan of Morocco and His Entourage* (1845).

If the Muslim East was the alluring exotic world outside Europe, an exotic subculture could be found within Europe as well, that of

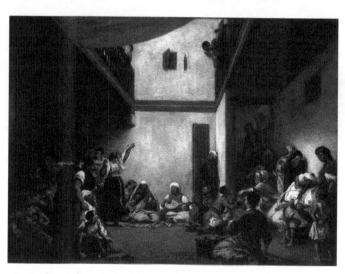

14. Eugène Delacroix, *Jewish Wedding in Morocco* (c. 1839). Delacroix had attended a Jewish wedding during his North African tour, during which he made sketches that served him for many years. He considered his visit to this 'oriental' world more important to his artistic growth than the customary sojourn in Rome would have been

the Gypsies, equally alluring and even somewhat 'oriental' too. ('Gypsies' is a misnomer, for the Roma, as they usually call themselves, did not come from Egypt but from northern India.) Groups had migrated to virtually every country of Europe, and continued to migrate within those countries, often in their characteristic wagons, making a living by artisanal labour, horse-trading, fortune-telling, and smuggling. They kept to themselves by choice, but were often forced to do so by fearful establishments who saw them as lawless, even Satanic, interlopers. But their colourful costumes, brilliant music and dancing, and apparent freedom to come and go inevitably inspired Romantic daydreams.

Pushkin's poetic tale 'The Gypsies' (1824) extends the range of Gypsy freedom to sexual freedom, as the outlaw Russian Aleko, fleeing civilization, is brought by the passionate Gypsy girl Zemfira to her camp and claimed as her lover. For two years they live happily, freely, without cares; they have a child; Aleko feels no regrets for his former life. But then Zemfira feels bored by Aleko, shackled and restless, so she begins an affair with a young Gypsy. Though counselled by her wise father to grant her her freedom, Aleko cannot relinquish his 'rights': he kills Zemfira and her new lover, and then is banished from the tribe. Prosper Mérimée's prose novella *Carmen* (1845) has a similar tragic plot (he had read Pushkin's poem in Russian and later translated it into French), but is much better informed about Roma culture, which he had studied with some care. That tale, of course, is the basis for Bizet's brilliant opera *Carmen* (1875), which made use of Spanish and Gypsy melodies and rhythms. The third well-known idealized Gypsy girl is Esmeralda in Hugo's *Notre-Dame de Paris* (1831), mistitled *The Hunchback of Notre Dame* in English. Pushkin and Mérimée have contemporary settings, but Hugo sets his novel in 1482, about a half century after the Roma people arrived in the Paris region. He creates a well-organized underworld, both sinister and attractive, that inverts the hierarchy of the main culture. The beautiful young dancer Esmeralda attracts too much attention, and as the complex

plot comes to a climax, she is accused of murder and (unlike the Walt Disney version) captured and hanged.

Wordsworth's poem 'Gipsies' (1807) is surprisingly unsympathetic, as he upends the commonplace that Gypsies come and go by claiming that *he* did quite a bit of travelling one day, while the 'torpid' Gypsies he passed in the morning were still in the same spot when he returned in the evening. He seems to have forgotten his own praise of idleness in *Lyrical Ballads* and his critique of the world of getting and spending in the sonnet we have discussed. William Hazlitt sarcastically asks what Wordsworth has been doing that day: admiring a flower, perhaps, or writing a sonnet? Hazlitt defends the Gypsies as 'the only living monuments of the first ages of society. They are an everlasting source of thought and reflection on the advantages and disadvantages of the progress of civilization' ('On Manner', 1815?).

When the Roma arrived in Paris, they were called 'Bohemians' because they had passed through Bohemia at some point. That is what Hugo calls them, among other terms, in his novel; Hazlitt calls them 'Bohemian philosophers'. In the early 19th century, the word was applied to the subculture of Parisian artists and writers who lived a colourful, transient, 'gypsy' life with who knew what means of support. Henri Murger's collection of stories, *Scènes de la vie de Bohème* (1845), popularized this usage in French, as Thackeray's novel *Vanity Fair* (1848) did in English; Murger's stories were the basis of Puccini's opera *La Bohème* (1898). It seems only right that the Romantics' interest in the 'Bohemians' should be repaid with the Bohemian label, however mistaken.

Chapter 6
The arts

Romanticism was above all a movement of the arts. If all of its distinctive ideas, feelings, philosophies, and political visions were superseded (and there are those who say they have been), it would still have left us with an enduring legacy of great works of literature, music, painting, architecture, and ballet. Its lyric poetry, surely, was one of its glories, equalled only by the poetry of the Renaissance, and it inspired many fine novels, plays, and short stories. It is hard to imagine a major symphony orchestra today that does not regularly fill its concert halls with Romantic music. Though musicologists may debate whether Beethoven, for instance, should be seen as Romantic or as 'classical', Romanticism in music is generally held to begin with him, if only because he was hailed as 'Romantic' by E. T. A. Hoffmann and others, and to flourish throughout the 19th century, with Schubert, Schumann, Mendelssohn, Chopin, Liszt, Berlioz, Wagner, Rossini, Verdi, Dvorak, Brahms, Tchaikovsky, and Debussy, among many others. Art historians restrict 'Romanticism' to a briefer period, more or less in sync with literary historians; as an art movement it is said to have yielded to Realism and other trends by mid-century. Even so, it embraced such masters as Constable and Turner, Friedrich and Runge, Delacroix and Géricault, while such later schools as Impressionism, Symbolism, Expressionism, and Surrealism would all seem to have Romantic roots. For anyone whose

imaginative life relies on the arts, losing Romanticism would be like losing a limb, or a lobe of the brain.

Among the arts of Romanticism, as opposed to its worldview, are there commonalities? In this final chapter, I will try to sketch some parallels among the arts and consider whether something we might call a 'Romantic system of the arts' comes into view.

Content

The obvious place to begin, because it is the easiest to trace, is the content or subject of a good deal of music and painting, and especially of those works derived from literature. Opera, oratorios, and songs (such as German *Lieder*) are half-literary to begin with, and composers and librettists recycled almost everything written by Romantic authors. We have mentioned the operas based on Scott's novels; there were also several based on his poems, such as Rossini's *La donna del lago* (1819), from *The Lady of the Lake*. All of Schiller's plays were turned into operas, four of them by Verdi; the best known of these, because of its irresistible overture, is Rossini's *Guillaume Tell* (1829). Byron's plays and oriental tales were eagerly snatched up: there were several operas each of *The Giaour*, *The Bride of Abydos*, *The Corsair* (one by Verdi), *Lara*, *Parisina* (one by Donizetti), *Marino Faliero* (one by Donizetti again), and *Sardanapalus*. To these, we might add the operatic versions of Shakespeare's plays, for though he was not a Romantic, the enthusiastic reception of Shakespeare on the Continent, after long neglect and condescension by neoclassical critics, is a hallmark of Romanticism. The texts of Schubert's astonishing output of 600 *Lieder* would make an ample anthology of German Romantic and 'pre-Romantic' poetry, with everything from Ossian to Heinrich Heine.

More interesting in this context are the textless musical interpretations of Romantic works or themes, such as Berlioz's *Harold in Italy*, a symphony with viola obbligato (1834), though

apparently the Byronic title was an afterthought. Berlioz had already presented his *Symphonie Fantastique* (1830), which had a literary 'plot' described in programme notes. Franz Liszt composed a dozen 'symphonic poems' in the 1850s, inspired by works of Hugo, Lamartine, Schiller, Byron, and Shakespeare. Everyone wrote overtures, which were often performed apart from the works they were supposedly overtures to; this was indeed a distinctively Romantic genre. Berlioz wrote overtures to *Rob Roy* and *Waverley* by Scott, *The Corsaire* by Byron, and two plays by Shakespeare. The greatest overture may well be Mendelssohn's 'Hebrides Overture' (1829), also known as 'Fingal's Cave', which seems to capture the wavy motion of a boat visiting that legendary spot in alternation with what sounds like a distant battle scene of the sort we hear about in the songs of Fingal's son Ossian.

Delacroix, we saw in the last chapter, painted a great number of scenes from Romantic authors, to which we may add Shakespeare and Milton, and he was interested in the suffering poet, such as Tasso and Ovid, as we saw in Chapter 3. He also painted portraits of Chopin, George Sand, and the violin virtuoso Paganini. J. M. W. Turner painted a few literary subjects, but his great subject is nature at its most sublime, as in his alpine landscapes and stormy seascapes; yet here too, he is inspired by theories of the literary sublime and poetic accounts of it. So is Friedrich in Germany, with his scenes of mountains and mist, seashores and moon, and his near obsession with Gothic ruins reclaimed by nature.

Many Romantic poets, painters, and composers were drawn to evening and night. Twilight is 'the hour my pensive spirit loves', Helen Maria Williams writes in her sonnet to that hour (1786), the hour of sacred melancholy. In his *Hymns to the Night* (1800), Novalis believes that the ancient gods returned to great Night, which became 'the mighty womb of revelation'. In his sonnet 'To Evening' (1802), Foscolo tells it 'You always come as one my heart invokes: / To its secret ways you enter sweetly in.' On a 'Moonlit Night' (1837), Eichendorff says, his soul expanded and spread wide

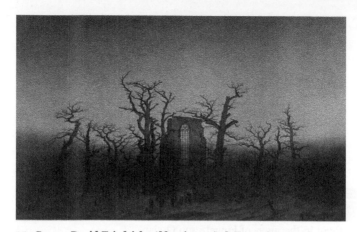

15. Caspar David Friedrich, *Abbey in an Oak Forest* (1809–10). Difficult to see in a small reproduction is a procession of monks entering the ruin. The painter Carl Gustav Carus (1789–1869) called this painting perhaps 'the most profound poetic work of art of all recent landscape painting'

its wings. Friedrich was the great painter of evening and night, and many other painters were intrigued by the challenge of catching the subtleties of twilight or moonlight. The 'nocturne' as a musical form is a Romantic invention, though the 'serenade' and 'notturno' were common in the 18th century simply as pieces played at night. It was the Irish composer John Field who first wrote piano pieces that sounded night-like, with quiet or dreamy melodies played against arpeggiated or broken chords in the left hand. Chopin heard them, and wrote 21 of his own, now widely held to be among his greatest solo piano pieces.

Form

A subtler influence of literature on music was the adoption of literary genres to name genres of music. The four ballades by Chopin are a prime example: these solo piano pieces of about ten minutes each seem (at least once the idea is planted by the title) to

have a narrative quality, as if some story is taking place. A good deal of fruitless ingenuity has been expended to correlate them with ballads by his compatriot Mickiewicz, though one early reviewer wrote, 'To listen to Chopin is to read a strophe by Lamartine.' Several composers wrote instrumental 'romances', the term referring not to the medieval narrative form but the more recent Spanish ballad or song. Beethoven's two *Romanzen* for violin and orchestra may be the best known, along with sets by both Robert and Clara Schumann. There were 'songs without words', notably those for piano by Mendelssohn, and more than one *Romance sans paroles*.

As some of these examples suggest, there was a trend in music towards shorter forms – nocturnes, overtures, impromptus, preludes, fantasias, *moments musicaux*, song cycles, and the like – that corresponds to the trend in literature toward lyric forms – sonnets, odes, 'effusions', *méditations*, *élégies*, and so on. With music, this was partly due to the growth of domestic performances, as middle-class families acquired the new pianoforte and put on their own concerts. Of course, there was a simultaneous growth in the great genres, especially after Beethoven doubled the scale of the symphony with his third, the 'Eroica' (1804). And poets continued to write, or had ambitions to write, epics. Yet shorter forms in both arts gained new prestige.

Was there anything comparable in painting? Among Romantic painters, it seems fair to say, landscapes and portraits grew in prominence, at the expense of 'history painting', which corresponded to the epic or tragedy as the noblest genre of its domain. Delacroix, it is true, painted grand historical and allegorical works, such as *The Death of Sardanapalus* (1827), but he is equally admired for his smaller scenes from North Africa and for his portraits. All but a few paintings by Turner, and virtually all by Friedrich and Constable, are landscapes.

If there was a rise in rank of the lesser genres, which disturbed the hierarchy established by neoclassicism, we can also discern a stretching or breaking up of the genres themselves. Wordsworth writes an epic autobiography in Miltonic blank verse, Shelley and Keats experiment with just about every possible rhyme scheme in the sonnet, Coleridge invents the blank-verse 'conversation poem' as well as irregular stanzas in *Christabel* (written in 1797 and 1800), which Scott then imitates in his own romances. Hugo shocks the fastidious with his daring placement of the caesura, a metrical pause, in his alexandrines. Though many Romantics aspired to success on the stage, some also wrote unperformable closet dramas: Goethe's *Faust* Part Two, Byron's *Manfred*, Shelley's *Prometheus Unbound*, Mickiewicz's *Forefathers' Eve*. Composers pushed the classical sonata form – with its two contrasting themes in different keys, first expounded, usually twice, then developed, then recapitulated – to its limit and beyond. In Chopin's ballades, for example, we can trace two themes, stated and developed, but they undergo variations even in the 'exposition', while there are extensive transitions and digressive episodes, sometimes a third theme, and usually a long coda. In Beethoven's hands, the symphony not only ballooned in scale but embraced, gloriously, a choral final movement.

As part of the trend towards shorter forms, it was characteristic of Romantic writers to publish deliberate fragments, as opposed to accidental fragments such as the remains of Sappho's poems or, if Macpherson were to be believed, Ossian's. Goethe's *Faust: Ein Fragment* (1790) lent prestige to the idea, and soon fragments of every genre were proliferating. Friedrich Schlegel's *Critical Fragments* (1798) and *Athenaeum Fragments* (1800) were seminal contributions to Romantic theory and to the theory of the fragment itself. 'Many of the works of the ancients have become fragments', he writes. 'Many modern works are fragments as soon as they are written' (*AF* 24, tr. Firchow). By these modern fragments, Schlegel means works that were ostensibly complete and rounded out in their form but were really just a collection of imaginative moments.

It is more honest to stop writing when a piece loses its inspiration and to name it a fragment. This Coleridge did in 'Kubla Khan: Or, A Vision in a Dream. A Fragment' (written 1797), and Byron did in *The Giaour: A Fragment of a Turkish Tale* (first edition 1813), though Coleridge offered a questionable excuse (he was interrupted by a visitor), and Byron kept adding fragments to subsequent editions. Several of Pushkin's poems are labelled 'fragment' (*otryvok*). These and many other supposed 'fragments' seemed to attract by teasing, by rousing the reader's imagination to fill in the gaps.

Is there something comparable in painting and music? The exhibitions and salons at this time were not likely to include a manifestly unfinished work, but some of the finished work of Turner and Delacroix, for example, struck viewers as sketches because of their rough brushwork. And it was not long before sketches, studies, and pencil drawings of various sorts were shown, at least in studios, and cherished for their spontaneity and seeming closeness to their original inspiration. Many musicians were capable improvisers and would often devote parts of public concerts to creating pieces on themes suggested by the audience. Chopin's short piano pieces, notably the *Preludes*, struck some listeners as unfinished, and were preludes to nothing, while Charles Rosen has recently argued that several pieces by Chopin and Schumann are fragmentary in a musical sense in that they end on a dominant seventh chord, which does not sound resolved but rather a preparation for a modulation to another key, or they begin in an ambiguous key and thus seem to be emerging from a transition from nothing. It is not surprising that a discussion of Chopin elicited from Delacroix a defence of sketches:

> We spoke of Chopin. He [a friend] told me that his improvisations were much bolder than his finished compositions. It is the same, no doubt, with a study for a painting compared with the finished picture. No, one doesn't spoil a painting by finishing it! Perhaps there is less room for the imagination than in a sketchy work.

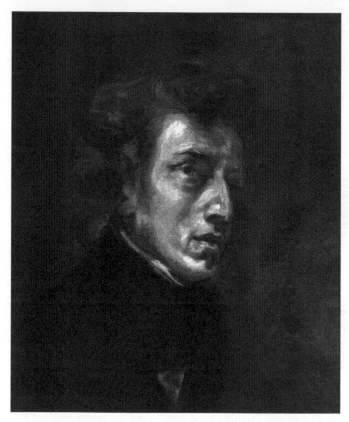

16. Eugène Delacroix, *Frédéric Chopin* (1838). This was originally part of a double portrait of Chopin sitting at the piano and George Sand looking on. Chopin is looking off, away from the piano, as if in a trance while improvising a piece

The prestige of music

We will conclude this very short account of some of the parallels among the arts with a look at the emergence of music as the norm of all art. According to the tradition of the 'sister arts', the closest

sister to poetry is painting. Simonides of Ceos claimed that painting is mute poetry, poetry a speaking picture, while Horace said, *ut pictura poesis*, 'as is a picture, so is poetry'. Perhaps the intimate connection between poetry and music was too obvious to the ancients to need stating, but by the 18th century, modern neoclassicists had repeated these sayings about painting so often that the kinship with music seemed forgotten. The Romantics revived it, especially in Germany, and dislodged painting from its privileged rank. Kleist regarded the art of music 'as the algebraic formula of all the others'. Friedrich Schlegel, in his novel *Lucinde*, describes 'How happy Julius was when he talked with her about music and heard from her mouth his own inmost thoughts about the sacred enchantment of this romantic art!' E. T. A. Hoffmann agreed that music is the most romantic art, and perhaps the only romantic one. 'No colour is as Romantic as a tone', wrote Jean Paul. Heine declared music to be 'art's final word'.

This exaltation of music is especially strong in Germany, home of musicians – indeed many German poets were themselves good musicians – but it can be found in France and even in unmusical Britain. Coleridge thought a man of mere talent could incorporate visual imagery in his poetry, 'But the sense of musical delight, with the power of producing it, is a gift of imagination.' Wordsworth wrote a poem called 'The Power of Music'. If Keats was fascinated by the sight of a Grecian urn, he was even more rapt by the song of a nightingale. Music pervades Shelley's poetic world as the great medium of love and communion, not only between people but, in *Prometheus Unbound*, between planets – the music of the spheres.

Madame de Staël holds music to be the foremost of the arts, and the highest praise given to Corinne's poetry is that it is an 'intellectual melody'. George Sand shares her opinion, and several of her novels are devoted to music or musicians. Lamartine names a volume of poems *Harmonies* (1830), while an old song transports Nerval in 'Fantaisie' (1832). Imagery like Shelley's is found in

Baudelaire's 'La Musique' (1857). Even a poem often considered the quintessence of pictorialism, Gautier's 'Symphonie en blanc majeur' (1852), has a musical title and, one might argue, a musical method. Late in the century, Verlaine issues a poetic manifesto, 'Art poétique' (1884), in which he calls on poets to take 'eloquence' and wring its neck, while filling their poems with 'music, above all else', 'music, again and always'.

In literature, the revival of lyric forms attests indirectly to the growing prestige of music; indeed, the very word 'lyric' was in origin a musical term. So, in Britain, we find narrative forms becoming lyricized, as certain titles witness: 'Lyrical Ballads' by Wordsworth and Coleridge (1798), 'Lyrical Tales' by Mary Robinson (1800), *Prometheus Unbound: A Lyrical Drama in Four Acts* by P. B. Shelley (1820). More intriguing is the question whether painting, no longer the favourite sister of poetry, became musicalized. The rough and rapid 'painterly' brushwork that is often taken as a hallmark of Romantic style (despite the more 'linear' work of Friedrich, Runge, and Blake) might be considered 'musical' in some way. The origins of abstract painting are sometimes traced to Turner and other Romantics. As painting became more and more non-representational through the century, or represented less and less imitatively the external world, it took on the characteristics of its non-representational sister. Delacroix thought harmony in painting worked the same way as harmony in music, 'in the makeup of the chords, but also in their relationships'. Baudelaire praised Delacroix's musical art in similar terms: 'These wonderful *chords* of color often give one ideas of melody and harmony, and the impression that one takes away from his pictures is often, as it were, a musical one.' And so it seems inevitable that the controversial near-abstract painting of Whistler's should have the musical title *Nocturne in Black and Gold* (1875); it was one of at least six 'nocturne' paintings which, among others titled 'Symphony' or 'Harmony', directed the viewer to the paintings' purely formal properties. At about the same time, Walter Pater summed up this Romantic trend in his book *The Renaissance*

(1873) with his celebrated declaration, 'All art constantly aspires toward the condition of music.'

Whether these parallels and interactions amount to a system, as against a mere constellation, is certainly debatable. I think they do: they gravitate around each other like a complicated cluster of stars and planets. But they kept changing, as new schools of literature, art, and music succeeded each other ever more rapidly through the 19th century. Some would argue that Romanticism was a mere rebellion, and that it simply dissolved the neoclassical system that preceded it, but I think Romanticism was a revolution, and tended for a while towards a new system, unstable and incomplete though it was, with many widespread recurrences in form and style as well as theme. Indeed, it was the last revolution, for no movement in any of the arts since then has been as long, deep, influential, and coherent.

Further reading

The literature on Romanticism is enormous. This short list confines itself to books in English and, with a few exceptions, to books that deal with more than one country or more than one art.

Anthologies of primary texts

Warren Breckman (ed.), *European Romanticism: A Brief History with Documents* (Boston: Bedford/St Martin's, 2008). A brief collection of prose and poetry from British, German, French, and Italian writers.

Michael Ferber (ed.), *European Romantic Poetry* (New York: Pearson Longman, 2005). Translations of sixty poets originally in German, French, Italian, Spanish, Galician, Russian, Polish, and Hungarian, with full annotations.

Lilian Furst (ed.), *European Romanticism: Self-Definition* (London: Methuen, 1980). Texts about Romanticism originally in English, German, and French.

Howard Hugo (ed.), *The Portable Romantic Reader* (New York: Viking, 1957). Poetry and prose from British, American, German, and French writers and composers. Out of print but worth tracking down.

General

M. H. Abrams, *Natural Supernaturalism: Tradition and Revolution in Romantic Literature* (New York: Norton, 1971). The 'high Romantic argument' in mainly British and German poets and philosophers.

Paul Bénichou, *The Consecration of the Writer, 1750–1830*, tr. Mark K. Jensen (Lincoln, NE: University of Nebraska, 1999). The emergence of French Romanticism.

Isaiah Berlin, *The Roots of Romanticism* (Princeton: Princeton University Press, 1991). (Based on lectures given in 1965.) Mainly on early German Romanticism; the influence of Hamann, Herder, Kant.

Rupert Christiansen, *Romantic Affinities: Portraits from an Age, 1780–1830* (London: Bodley Head, 1988). Lively biographical vignettes.

Maurice Cranston, *The Romantic Movement* (Oxford: Blackwell, 1994). Brief chapters on German, English, French, Italian, and Spanish Romanticism.

Michael Ferber (ed.), *A Companion to European Romanticism* (Oxford: Blackwell, 2005). Essays on German, French, Italian, Spanish, Russian, and Polish Romantic literature and song, as well as on themes and forms.

Northrop Frye, *A Study of English Romanticism* (New York: Random House, 1968).

Robert F. Gleckner and Gerald E. Enscoe (eds.), *Romanticism: Points of View*, 2nd edn. (Detroit: Wayne State University Press, 1970). Has excerpts of essays by Hulme, Lovejoy, and Wellek cited in this book.

Michael Löwy and Robert Sayre, *Romanticism Against the Tide of Modernity*, tr. Catherine Porter (Durham, NC: Duke University Press, 2001). Romanticism as a worldview critical of modern capitalism.

Patrick Vincent, *The Romantic Poetess: European Culture, Politics and Gender, 1820–1840* (Durham, NH: University of New Hampshire Press, 2004). British, French, and Russian women poets.

Sensibility

Louis I. Bredvold, *The Natural History of Sensibility* (Detroit: Wayne State University Press, 1962).

Northrop Frye, 'Towards Defining an Age of Sensibility', *English Literary History*, 23:2 (1956). Reprinted in Frye, *Fables of Identity* (New York: Harcourt Brace, 1963).

Janet Todd, *Sensibility: An Introduction* (London: Methuen, 1986).

Philosophy

Frederick C. Beiser, *German Idealism: The Struggle Against Subjectivism, 1781–1801* (Cambridge, MA: Harvard University Press, 2002). The second half, on 'Absolute Idealism', is about Schelling and the Romantics.

Frederick C. Beiser, *The Romantic Imperative: The Concept of Early German Romanticism* (Cambridge, MA: Harvard University Press, 2003).

Science

Richard Holmes, *The Age of Wonder: How the Romantic Generation Discovered the Beauty and Terror of Science* (New York: Pantheon, 2008). Largely on British scientists, but with sections about poets as well.

Laura Otis (ed.), *Literature and Science in the Nineteenth Century: An Anthology* (Oxford: Oxford University Press, 2002). Rich collection of short excerpts from scientific writings (mainly British, with a few from the Continent) and literary works (mainly British and American).

Robert J. Richards, *The Romantic Conception of Life: Science and Philosophy in the Age of Goethe* (Chicago: University of Chicago Press, 2002). Mainly on German thought.

Music

Leon Plantinga, *Romantic Music* (New York: Norton, 1984).

Charles Rosen, *The Romantic Generation* (Cambridge, MA: Harvard University Press, 1995).

Richard Taruskin, *The Oxford History of Western Music, vol. 3: The Nineteenth Century* (Oxford: Oxford University Press, 2005).

Art

David Blayney Brown, *Romanticism* (London: Phaidon, 2001).

Kenneth Clark, *The Romantic Rebellion: Romantic versus Classic Art* (New York: Harper and Row, 1973).

Hugh Honour, *Romanticism* (New York: Harper and Row, 1979).

William Vaughan, *Romanticism and Art*, revised edn. (London: Thames and Hudson, 1994).

Norbert Wolf, *Painting of the Romantic Era* (Köln: Taschen, 1999).

Appendix of Names

Abrams, M. H. (1912–), American literary scholar

Akenside, Mark (1721–70), English poet

Anderson, Benedict (1936–), English/American political scientist

Aristophanes (c. 445 – c. 385 BCE), Greek comedian

Arnim, Ludwig Achim von (1781–1831), German poet and collector of folk songs

Arnold, Matthew (1822–88), English poet and essayist

Auden, W. H. (1907–73), English poet

Austen, Jane (1775–1817), English novelist

Bacon, Francis (1561–1626), English philosopher and Lord Chancellor

Baratynsky, Evgeny (1800–44), Russian poet

Batyushkov, Konstantin (1787–1855), Russian poet

Baudelaire, Charles (1821–67), French poet

Beattie, James (1735–1803), Scottish scholar and poet

Beethoven, Ludwig van (1770–1827), German composer

Bellini, Vincenzo (1801–35), Italian opera composer

Bentham, Jeremy (1748–1832), English utilitarian philosopher and reformer

Berlioz, Hector (1803–69), French composer

Bizet, Georges (1838–75), French composer

Blake, William (1757–1827), English poet and engraver

Bloom, Harold (1930–), American literary scholar

Bowles (later Southey), Caroline (1786–1854), English poet

Brahms, Johannes (1833–97), German composer

Brentano, Clemens (1778–1842), German poet and collector of folk songs

Brown, Marshall (1945–), American literary scholar

Browne (later Gray), Mary (1812–45), English poet
Browning, Elizabeth Barrett (1806–61), English poet
Brun, Friederike (1765–1835), Danish poet of German origin
Bürger, Gottfried August (1747–94), German poet
Burke, Edmund (1729–97), Anglo-Irish parliamentarian and political philosopher
Burns, Robert (1759–96), Scottish poet
Byron, Lord (George Gordon) (1788–1824), English/Scottish poet
Calderón de la Barca, Pedro (1600–1681), Spanish playwright
Campbell, Thomas (1777–1844), Scottish poet
Carlyle, Thomas (1795–1881), Scottish essayist and historian
Cervantes Saavedra, Miguel de (1547–1616), Spanish novelist and poet
Chateaubriand, François René de (1768–1848), French novelist, essayist, and diplomat
Chatterton, Thomas (1752–70), English poet
Chaucer, Geoffrey (c. 1343–1400), English poet
Chénier, André (1762–94), French poet
Chopin, Frédéric (1810–49), Polish-French composer and pianist
Coleridge, Samuel Taylor (1772–34), English poet and literary theorist
Collins, William (1721–59), English poet
Constable, John (1776–1837), English painter
Copernicus, Nicolaus (1473–1543), Polish astronomer
Corinna of Tanagra (dates disputed, perhaps 5th century BCE)
Coronado, Carolina (1823–1911), Spanish poet
Cowper, William (1731–1800), English poet
Dante Alighieri (1265–1321), Italian poet
Darwin, Charles (1809–82), English naturalist and biologist
Darwin, Erasmus (1731–1802), English physician, natural philosopher, and poet
David, Félicien-César (1810–76), French composer
Davy, Humphry (1778–89), English chemist, inventor, and poet
Debussy, Claude (1862–1918), French composer
Defoe, Daniel (c. 1659–1731), English novelist and journalist
Delacroix, Eugène (1798–1863), French painter
Denne-Baron, Sophie (1785–1861), French poet
Derzhavin, Gavrila Romanovich (1743–1816), Russian poet

Deschamps, Émile (1791-1871), French poet and editor

Descartes, René (1596-1650), French philosopher and mathematician

Dickens, Charles (1812-70), English novelist

Diderot, Denis (1713-84), French philosopher, art critic, and novelist

Domitius Marsus (c. 50-c. 0 BCE), Latin poet

Donizetti, Gaetano (1797-1848), Italian composer

Droste-Hülshoff, Annette von (1797-1848), German poet

Dryden, John (1631-1700), English poet

Dufrénoy, Adélaïde (1765-1825), French poet

Dumas, Alexandre (père) (1802-70), French novelist

Dürer, Albrecht (1471-1528), German painter and engraver

Dvorak [or Dvořák], Antonin (1841-1904), Czech composer

Eichendorff, Joseph Freiherr von (1788-1857), German poet and novelist

Einstein, Albert (1879-1955), German-Swiss-American physicist

Emerson, Ralph Waldo (1803-82), American poet and essayist

Erinna (c. 600 BCE), Greek poet

Fichte, Johann Gottlieb (1762-1814), German philosopher

Field, John (1782-1837), Irish composer and pianist

Foscolo, Ugo (1778-1827), Italian poet

Friedrich, Caspar David (1774-1840), German painter

Frye, Northrop (1912-91), Canadian literary scholar

Galileo Galilei (1564-1642), Italian scientist

Gall, Franz Joseph (1758-1828), German physiologist and phrenologist

Galvani, Luigi (1737-98), Italian physician and experimenter with electricity

Gandhi, Mohandas ("Mahatma") (1869-1948), leader of India's
nonviolent independence movement

Gautier, Théophile (1811-72), French poet

Gérard, François (1770-1837), French painter

Géricault, Théodore (1791-1824), French painter

Gilbert, Laurent (1751-80), French poet

Ginsberg, Allen (1926-97), American poet

Girodet (Anne-Louis Girodet de Roussy-Trioson) (1767-1824), French painter

Godwin, Catherine Grace (1798-1845), English poet

Godwin, William (1756-1836), English philosopher and novelist

Goethe, Johann Wolfgang von (1749-1832), German poet, playwright,
novelist, and essayist

Gogol, Nikolai (1809–52), Russian-Ukrainian novelist

Goldsmith, Oliver (1730–74), Anglo-Irish poet and novelist

Görres, Johann Joseph von (1776–1848), German essayist and journalist

Gray, Thomas (1716–71), English poet

Grillparzer, Franz (1791–1872), Austrian playwright

Grimm, Jacob (1785–1863), German philologist and collector of folktales

Günderode, Karoline von (1780–1806), German poet

Hamann, Johann Georg (1730–88), German philosopher

Hawthorne, Nathaniel (1804–64), American novelist

Hazlitt, William (1778–1830), English essayist and journalist

Hegel, Georg Wilhelm Friedrich (1770–1831), German philosopher

Heine, Heinrich (1797–1856), German poet

Hemans, Felicia (1793–1835), English poet

Herder, Johann Gottfried (1744–1803), German philosopher, historian, literary critic Herschel, Frederick William (Friedrich Wilhelm) (1738–1822), German-British astronomer

Hesiod (c. 700 BCE), Greek poet

Hobbes, Thomas (1588–1679), English philosopher

Hobsbawm, Eric (1917–), English historian

Hoffman, E. T. A. (1776–1822), German story-writer, composer, and music critic

Hölderlin, Friedrich (1770–1843), German poet

Homer (c. 700 BCE), Greek poet

Horace (Quintus Horatius Flaccus) (65–8 BCE), Roman poet

Howard, Luke (1772–1864), English meteorologist and chemist

Hugo, Victor (1802–85), French poet, playwright, and novelist

Hulme, T. E. (1883–1917), English critic

Humboldt, Wilhelm von (1767–1835), German philosopher and linguist

Hume, David (1711–76), Scottish philosopher and historian

Hunt, Leigh (1784–1859), English essayist and poet

Hurd, Richard (1720–1808), English bishop and essayist

Hutton, James (1726–97), Scottish geologist

Ingres, Jean Auguste Dominique (1780–1867), French painter

Ireland, William Henry (1775–1835), poet and forger of Shakespeare documents

Jacobi, F. H. (1743–1819), German philosopher

Johnson, Samuel (1709–84), English essayist, poet, biographer, and lexicographer

Jones, William (1746–94), English philologist

Kant, Immanuel (1724–1804), German philosopher

Karamzin, Nikolay Mikhailovich (1766–1826), Russian historian and poet

Keats, John (1795–1821), English poet

Kerouac, Jack (1922–69), American novelist

Kircher, Athanasius (1601–80), German Jesuit scientist and polymath

Kleist, Heinrich von (1777–1811), German playwright

Klinger, Friedrich (1752–1831), German playwright

Klopstock, Friedrich Gottlieb (1724–1803), German poet

Kulman, Elizaveta (1808–25), Russian poet

Lamartine, Alphonse de (1790–1869), French poet

Lamb, Charles (1775–1834), English essayist

Lamennais, Hugue Félicité Robert de (1782–1854), French priest and philosopher

Landon, Letitia Elizabeth (1802–38), English poet

Landor, Walter Savage (1775–1864), English poet

Leibniz, Gottfried (1646–1716), German philosopher and mathematician

Leonardo da Vinci (1442–1519), Italian artist and inventor

Leopardi, Giacomo (1798–1837), Italian poet

Lermontov, Mikhail (1814–41), Russian poet and novelist

Lessing, Gotthold Ephraim (1729–81), German playwright and philosopher

Le Sueur, Jean-François (1760–1837), French composer

Lewis, Matthew (1776–1818), English novelist and playwright

Liszt, Franz (Ferenc) (1811–86), Hungarian composer and pianist

Locke, John (1632–1704), English philosopher

Longinus (first or third century CE), conventional name for unknown author of On the Sublime

Lovejoy, A. O. (1873–1962), American literary scholar

Lowth, Robert (1710–87), English bishop, grammarian, and Bible scholar

Loyson, Charles (1791–1820), French poet

Lucan (Marcus Annaeus Lucanus) (39–65 CE), Roman poet

Machiavelli, Niccolò (1469–1527), Italian diplomat and political philosopher

Macpherson, James (1736–96), Scottish writer and "translator" of Ossian

Malfilâtre, Jacques-Charles-Louis Clinchamps de (1733–67), French poet

Manzoni, Alessandro (1785–1873), Italian poet and novelist

Mendelssohn, Felix (1809–47), German composer

Mérimée, Prosper (1803–70), French darmatist and novella-writer

Michelangelo (1475–1564), Italian painter, sculptor, and architect

Mickiewicz, Adam (1798–1855), Polish-Lithuanian poet

Millevoye, Charles Hubert (1782–1816), French poet

Milton, John (1608–74), English poet and essayist

Moore, Thomas (1779–1852), Irish poet

Murger, Henri (1822–61), French poet and novelist

Musset, Alfred de (1810–57), French poet and playwright

Napoleon Bonaparte (1769–1821), French general, consul, and emperor

Nascimento, Francisco Manoel do (1734–1819), Portuguese poet

Nerval, Gérard de (1808–55), French poet

Newton, Isaac (1643–1727), English physicist and mathematician

Nodier, Charles (1780–1844), French story-writer

Novalis (Georg Philipp Friedrich Freiherr von Hardenberg)
(1772–1801), German poet and novelist

Ossian, son of Fingal (legendary third-century Gaelic bard)

Ovid (Publius Ovidius Naso) (43 BCE – c. 17 CE), Roman poet

Paganini, Niccolò (1782–1840), Italian violinist and composer

Parini, Giuseppe (1729–99), Italian poet

Pater, Walter (1839–94), English essayist and art critic

Paul, Jean (Johann Paul Friedrich Richter) (1763–1825), German novelist
and story-writer

Percy, Thomas (1729–1811), English bishop and collector of ballads

Petöfi, Sándor (1823–1849?), Hungarian poet

Pindar (c. 522–443 BCE), Greek poet

Poe, Edgar Allan (1809–49), American poet and story-writer

Pope, Alexander (1688–1744), English poet

Puccini, Giacomo (1858–1924), Italian opera-composer

Pushkin, Alexander (1799–1837), Russian poet and story-writer

Raphael (1483–1520), Italian painter

Richardson, Samuel (1689–1761), English novelist

Rimbaud, Arthur (1854–91), French poet

Robespierre, Maximilien (1758–94), French revolutionary leader

Robinson, Mary (1757–1800), English poet

Rosen, Charles (1927–), American pianist and musicologist

Rossini, Gioachino (1792–1868), Italian opera-composer

Rousseau, Jean-Jacques (1712–78), Swiss philosopher and novelist

Runge, Philipp Otto (1777–1820), German painter

Sainte-Beuve, Charles-Augustin (1804–69), French critic and poet

Sand, George (pen name of Amantine Aurore Lucile Dupin) (1804–76), French novelist

Sappho of Lesbos (c. 620–c. 570 BCE), Greek poet

Schelling, Friedrich Wilhelm Joseph (1775–1854), German philosopher

Schiller, Johann Christoph Friedrich (1759–1805), German poet, playwright, and philosopher

Schlegel, August Wilhelm (1767–1845), German literary scholar, translator, and poet

Schlegel, Dorothea (1764–1839), German novelist and translator

Schlegel, Karl Wilhelm Friedrich (1772–1829), German literary critic and poet

Schleiermacher, Friedrich Daniel Ernst (1768–1834), German theologian and philosopher

Schubert, Peter Franz (1797–1828), Austrian composer

Schumann, Clara Wieck (1819–96), German pianist and composer

Schumann, Robert (1810–56), German composer, pianist, and music critic

Scott, Walter (1771–1832), Scottish poet and novelist

Second, Jean (Jan Everaerts) (1511–36), Dutch humanist and Latin poet

Shaftesbury, 3rd Earl of (Anthony Ashley Cooper) (1671–1713), English philosopher and politician

Shakespeare, William (1564–1616), English playwright and poet

Shelley, Mary Wollstonecraft Godwin (1797–1851), English novelist

Shelley, Percy Bysshe (1792–1822), English poet

Simonides of Ceos (c. 556–468 BCE), Greek poet

Smart, Christopher (1722–71), English poet

Smith, Adam (1723–90), Scottish philosopher and political economist

Smith, Charlotte (1749–1806), English poet and novelist

Solomos, Dionysios (1798–1857), Greek poet

Southey, Robert (1774–73), English poet, essayist, and historian

Spenser, Edmund (c. 1552–99), English poet

Spinoza, Baruch (Benedict) de (1632–77), Dutch/Jewish/Portuguese philsopher

Staël, Anne Louise Germaine de (1766–1817), French-Swiss novelist and essayist

Tasso, Torquato (1544–95), Italian poet

Tastu, Amable (1798–1885), French poet

Tchaikovsky, Pyotr Ilyich (1840–93), Russian composer

Tennyson, Alfred, Lord (1809–92), English poet

Tetens, Johannes Nikolaus (1736–1807), German philosopher and mathematician

Thackeray, William Makepeace (1811–63)

Thelwall, John (1764–1834), English orator, political organizer, and poet

Theocritus (3rd century BCE), Greek poet

Thomson, James (1700–48), Scottish poet

Tibullus, Albius (c. 54–19 BCE), Roman poet

Tieck, Johann Ludwig (1773–1853), German poet, novelist, and translator

Turner, J. M. W. (1775–1851), English painter

Verdi, Giuseppe (1813–1901), Italian opera composer

Verlaine, Paul (1844–96), French poet

Vigny, Alfred de (1797–1863), French poet and playwright

Virgil (Publius Vergilius Maro) (70–19 BCE), Roman poet

Volta, Alessandro (1745–1827), Italian physicist

Wackenroder, Wilhelm Heinrich (1773–98), German poet and essayist

Wagner, Richard (1813–83), German composer

Walpole, Horace (1717–97), English novelist and art historian

Warton, Thomas, Jr. (1728–90), English poet and literary historian

Weber, Max (1864–1920), German sociologist and social theorist

Wellek, René (1903–95), Czech-American literary scholar

Whistler, James McNeill (1834–1903), American painter

Whitman, Walt (1819–92), American poet

Williams, Helen Maria (1761/2–1827), English poet

Wittgenstein, Ludwig (1889–1951), Austrian-British philosopher

Wollstonecraft, Mary (1759–97), English essayist and novelist

Wordsworth, William (1770–1850), English poet

Yeats, William Butler (1865–1939), Irish poet and playwright

Young, Edward (1681–1765), English poet

Zhukovsky, Vasily (1783–1852), Russian poet

Index

Note: All personal names in the Index are identified in the Appendix. To save space the Index omits those names mentioned only once in the text.

Romanticism

PHILOSOPHY
A Very Short Introduction
Edward Craig

This lively and engaging book is the ideal introduction for anyone who has ever been puzzled by what philosophy is or what it is for.

Edward Craig argues that philosophy is not an activity from another planet: learning about it is just a matter of broadening and deepening what most of us do already. He shows that philosophy is no mere intellectual pastime: thinkers such as Plato, Buddhist writers, Descartes, Hobbes, Hume, Hegel, Darwin, Mill and de Beauvoir were responding to real needs and events – much of their work shapes our lives today, and many of their concerns are still ours.

'A vigorous and engaging introduction that speaks to the philosopher in everyone.'

John Cottingham, University of Reading

'addresses many of the central philosophical questions in an engaging and thought-provoking style ... Edward Craig is already famous as the editor of the best long work on philosophy (the Routledge Encyclopedia); now he deserves to become even better known as the author of one of the best short ones.'

Nigel Warburton, The Open University

www.oup.co.uk/isbn/0-19-285421-6

THE FRENCH REVOLUTION

A Very Short Introduction

William Doyle

Beginning with a discussion of familiar images of the French Revolution, garnered from Dickens, Baroness Orczy, and Tolstoy, this short introduction leads the reader to the realization that we are still living with the legacy of the French Revolution. It destroyed age-old cultural, institutional, and social structures in France and beyond. William Doyle shows how the *ancien régime* became *ancien* as well as examining cases in which achievement failed to match ambition, exploring its consequences in the arenas of public affairs and responsible government, and ending with thoughts on why the revolution has been so controversial.

> 'A brilliant combination of narrative and analysis, this masterly essay provides the best introduction to its subject in any language.'
>
> **Tim Blanning, University of Cambridge**

www.oup.co.uk/isbn/0-19-285396-1

ROUSSEAU
A Very Short Introduction
Robert Wokler

Rousseau was both a central figure of the European
Enlightenment and its most formidable critic. In this study
of his life, works, sources, and influence, Robert Wokler
shows how Rousseau's account of the trappings of
civilization across a wide range of disciplines was inspired
by ideals of humanity's self-realization in a condition of
unfettered freedom.

'Remarkably well-informed . . . this at once chronological
and thematic treatment of Rousseau's thought makes
plain its unity and coherence. Addressing both
philosophical and political sources as well as influences,
the work includes a fine bibliographical commentary . . .
and commends itself through the clarity of its exposition
and the rigour of its analysis.'

Raymond Trousson, *Dix-huitieme siecle*

'One of the best-informed, most balanced, short general
introductions to Rousseau . . . in English. . . . Wokler's
study leaves a vivid impression of Rousseau's uniqueness
and originality as a thinker.'

Graeme Garrard, *History of Political Thought*

www.oup.co.uk/isbn/0-19-280198-8

ANARCHISM
A Very Short Introduction
Colin Ward

The word 'anarchism' tends to conjure up images of aggressive protest against government. But is anarchism inevitably linked with violent disorder? Do anarchists adhere to a coherent ideology? What exactly is anarchism?

In this Very Short Introduction, Colin Ward considers anarchism from a variety of perspectives: theoretical, historical, and international, and by exploring key anarchist thinkers from Kropotkin to Chomsky. Among the questions he ponders are: can anarchy ever function effectively as a political force? Is it more 'organized' and 'reasonable' than is currently perceived? Whatever the politics of the reader, Ward's argument ensures that anarchism will be much better understood after reading this book.

'excellent introduction' – **The Guardian**

http://www.oup.co.uk/isbn/0-19-280477-4